PAINTING
Sunlit Still Lifes
in WATERCOLOR

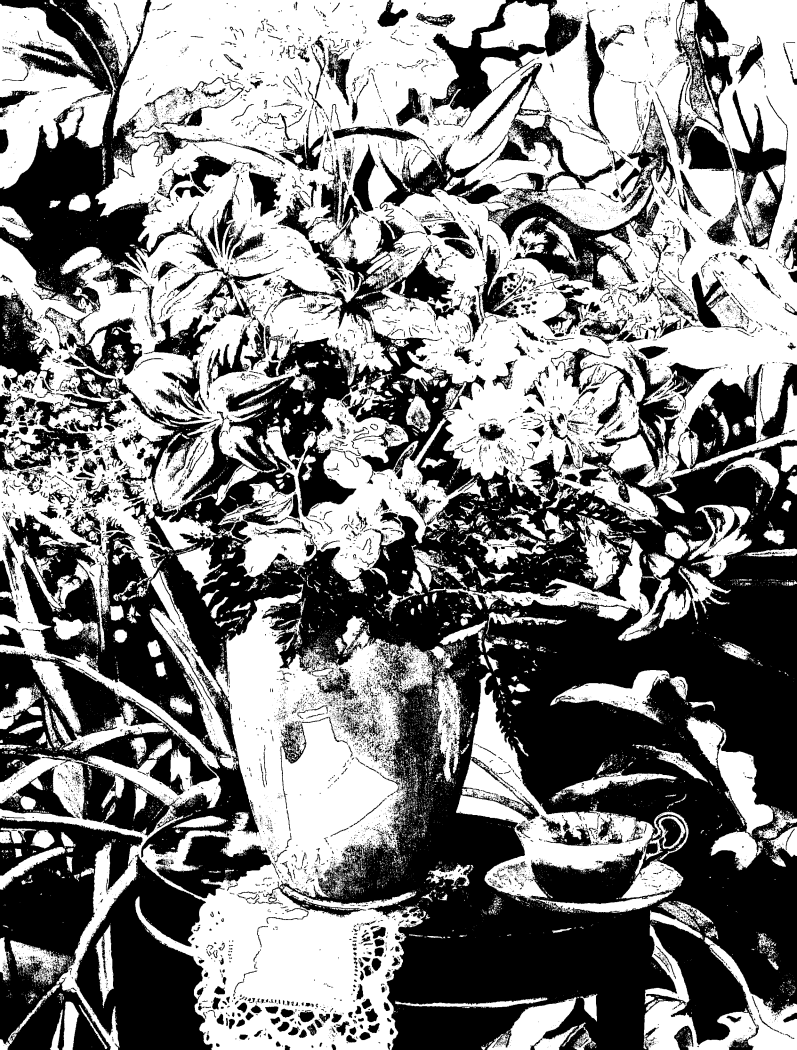

PAINTING
Sunlit
Still Lifes
in
WATERCOLOR

Liz Donovan

NORTH LIGHT BOOKS
CINCINNATI, OHIO

◄LILIES, 25" X 35" (56cm x 89cm)
Collection of the artist.

About the Author

PHOTO BY: KEITH WELLER

Liz Donovan is a signature member of the National Watercolor Society, as well as an active member of several other societies. She is the recipient of numerous awards, including being named a finalist several times in competitions of *The Artist's Magazine* and *American Artist*. She studied at the Corcoran School of Art in Washington, DC, The Maryland Institute College of Art in Baltimore, and with artists David Zuccarini, Don Stone, Jeanne Dobie, Alex Powers and Tony Couch.

Liz lives with her husband, Dick, and their Burnese Mountain Dog, Tank, in Glenwood, Maryland.

METRIC CONVERSION CHART

TO CONVERT	TO	MULTIPLY BY
Inches	Centimeters	2.54
Centimeters	Inches	0.4
Feet	Centimeters	30.5
Centimeters	Feet	0.03
Yards	Meters	0.9
Meters	Yards	1.1
Sq. Inches	Sq. Centimeters	6.45
Sq. Centimeters	Sq. Inches	0.16
Sq. Feet	Sq. Meters	0.09
Sq. Meters	Sq. Feet	10.8
Sq. Yards	Sq. Meters	0.8
Sq. Meters	Sq. Yards	1.2
Pounds	Kilograms	0.45
Kilograms	Pounds	2.2
Ounces	Grams	28.4
Grams	Ounces	0.04

01 00 99 98 97 5 4 3 2 1

Library of Congress Cataloging-in-Publication Data

Donovan, Liz
 Painting sunlit still lifes in watercolor / by Liz Donovan
 p. cm.
 Includes index.
 ISBN 0-89134-732-1(alk. paper)
 1. Still-life painting—Technique. 2. Watercolor painting—Technique. 3.
 Sunlight in art. I. Title.
ND2290.D66 1997
751.42'2435—dc21 96-49205
 CIP

Edited by Joyce Dolan and Pamela Seyring
Production Edited by Jennifer Lepore
Designed by Angela Lennert Wilcox

North Light Books are available for sales promotions, premiums and fund-raising use. Special editions or book excerpts can also be created to specification. For details, contact the Special Sales Manager, F&W Publications, 1507 Dana Avenue, Cincinnati, Ohio 45207.

Acknowledgments

Sincere thanks to Elizabeth Collard, who had the original idea for this book, outlined her idea and pitched it to North Light. Without her enthusiasm, energy and organizational skills I cannot imagine how this work ever would have materialized.

And to David Zuccarini, who taught me to think, see, paint and to appreciate the "Humble Truth" of still life.

Special thanks to Rachel Wolf, Pamela Seyring, Joyce Dolan and Jennifer Lepore, the North Light editors who worked on my project, for making sense of what I gave them and for their patience and tact when deadlines weren't met.

Lastly, but no less importantly, thank you to Tank, who was my faithful companion during the endless days and some nights I toiled away.

Dedication

Dedicated to my husband, Dick, whose encouragement and support have made all the good things in my life possible, including our three children, Kelly, Boo and Tim.

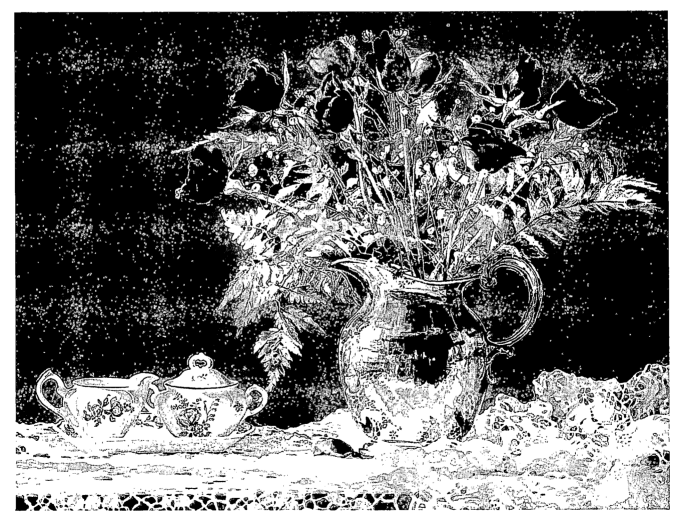

SILVER PITCHER OF ROSES, 20½" × 26½" (52cm × 67cm)
Private collection.

Table of Contents

Introduction

Most realist artists, if asked, will tell you light is the most important part of their paintings. Light gives an object the shadows and highlights that describe its form.

For me, sunlight gives an otherwise inert still life its movement and energy. Observe objects arranged on a windowsill with windowpane-shaped rectangles of sunlight falling on them. Some of these things may move slightly, the flowers will wilt, leaves will turn toward the light, but the sunlight spills, splashes, leaps and dances across your arrangement filling it with life and energy. Just look at all the words there are to describe the movement of sunlight!

The warm light of the sun infuses your paintings with rich hues and casts shadows full of reflected color. The lacy patterns and big luminous shapes of these shadows become as interesting as the objects themselves. Sunlight's patterns of light and shadow are a great device for integrating the objects of your still life into a pleasing design of light and dark values.

When I was a student in art school, some instructors had us draw for at least a year before we were allowed a paintbrush or color. I struggled with nearsightedness and an astigmatism that affected my drawing accuracy. Upon reading an article about one of the watercolorists I admire most, Carolyn Brady, I was excited to discover she mounted negatives of her photographs into slide mounts, projected the images onto her paper and used them to achieve accurate renderings.

By projecting photographs and slides, the artist learns to deal with value, design, color, quality of paint and the paintbrush while learning about proportion and line. The novice will grasp these concepts faster and see encouraging results sooner. You don't need to know how to draw a straight line to start painting. I'm not advising copying photographs in a paint-by-number manner, but with some background in perspective and composition, problems can be solved in the viewfinder of a camera, saving time and giving the artist confidence to attempt difficult subjects.

Line is, of course, an important part of your composition. But first you need the large shapes and values that are the main structure of the painting. If these don't work, no amount of beautifully painted, intricate detail will save it. Line should be the icing on your metaphorical cake.

As I describe the steps of painting the textures and shapes of various objects, it may be hard to understand how an effect was reached. This is probably because it was one of those moments of "Humble Truth" when the paint takes over, colors and values merge in just the right way and you, the artist, feel as though you are standing by and watching in amazement. I believe these mystical experiences are what compel artists to paint, whatever their style or subject matter. We conceive an idea, set the stage and invite the muse, and if she visits us for just a few brushstrokes we are content.

Glossary

Artist Grade vs. Student Grade
The highest quality of paint produced by a manufacturer versus a cheaper grade with more filler and less pigment.

Bloom
Feathered blotch caused by a wet wash running back into an almost dry wash.

Cold-Press Paper
Refers to how a paper is made and the surface that results. Cold-press paper has a textured surface but not as much as "Rough." (see Tooth)

Complementary Colors
Colors opposite each other on the color wheel: orange and blue, red and green, yellow and violet.

Concave
Hollowed or rounded inward like the inside of a bowl. When drawing things of nature, concave lines are weak and do not strengthen your design.

Convex
Curved or rounded like the exterior of a sphere or circle. Convex lines portray the bursting forth of growth and are considered strong marks or shapes.

Dry Brush
Painting with very little water mixed with the pigment on the brush so each stroke has a rough, dry texture.

Frisket
Used for saving critical whites for sunlit areas. Found in liquid, paper or film form. Liquid frisket is used for the demonstrations in this book.

Glazing
Brushing a transparent layer of paint over another layer, allowing the undercoat to show through.

Graying
Modifying a color's purity or saturation by adding its complement or another color to gray it down.

High-Key Color
Color on the light end of the value scale.

Highlight
The point of greatest light intensity on a form.

Hue
The name of a color.

Local Color
The natural or painted color of an object.

Luminosity
Glowing light.

Modify a Color
Change a color by graying or changing its hue.

Reflected Light
Light bouncing into shadows from the sky or nearby objects.

Refracted Light
The bending of light waves as they pass through one medium into another of a different density.

Saturated and Unsaturated Color
Pure color or grayed color.

Symmetry
Both sides of a dividing line or axis being equal.

Tooth
The surface texture of paper that affects how it holds paint.

Triad
Any three colors having a triangular relationship on the color circle. Primary triads would be red, yellow and blue. Secondary triads would be green, orange and violet.

Values
The relative lightness or darkness of a color.

Wet-in-Wet
Painting wet color onto a surface already wet with color or water.

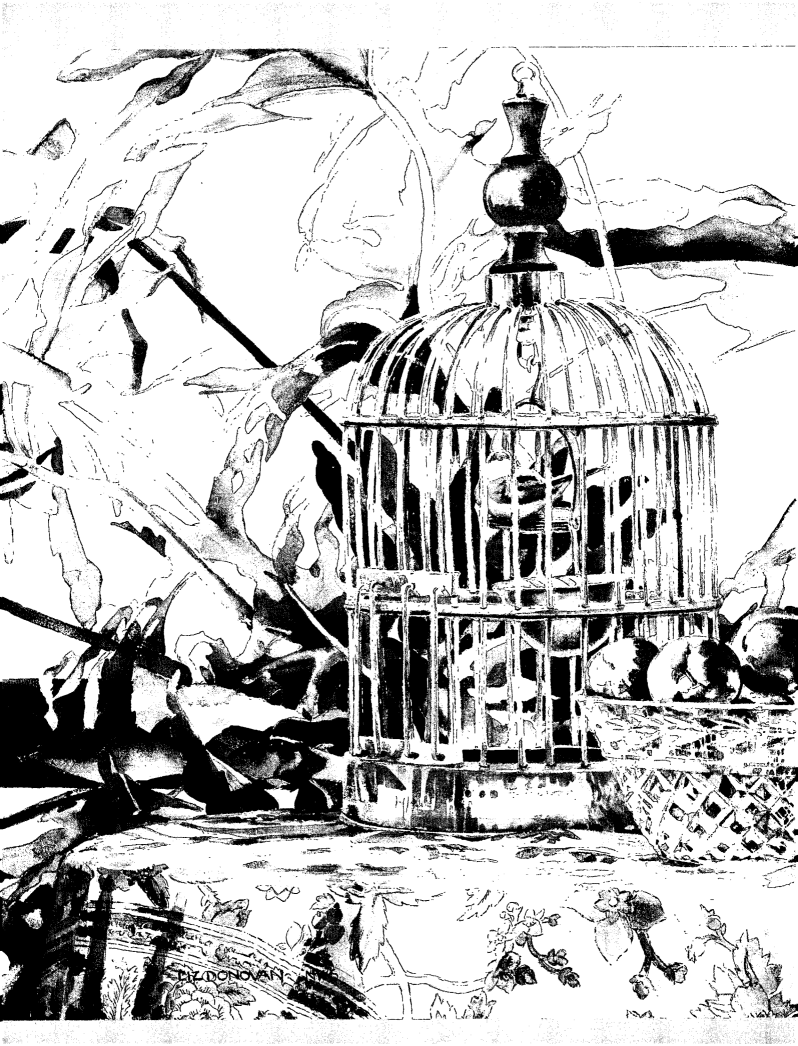

Putting Together a Sparkling Sunlit Composition

Paintings are more meaningful if you choose subjects you see often and know well. Flowers from your garden, family heirlooms or rusty junk from your garage can inspire masterpieces when put together with care. There's no limit to the possibilities for inspiration from your immediate surroundings when viewed with a new artistic eye. Notice the beautiful Burnt Sienna of a rusty piece of machinery. Lingering over breakfast in the morning, watch the shapes created by sun streaming in the window. Observe the long shadow cast by a window shutter when the sun is low in the sky. Don't hesitate to use the same objects repeatedly, because each lighting change brings new challenges. Create harmony in your still lifes by choosing objects related to one another. Repeat colors or use complementary colors; repeat curves, shapes or patterns in various sizes; use a recurring theme.

BIRD CAGE AND BOWL OF PLUMS, 22" × 30" (56cm × 76cm)
Collection of the artist.

Interesting Still Life Elements

In art, as in life, there are few absolutes. But if you put a great deal of thought into your composition from the start, there are ways to make your still life setup a foundation for success.

Harmony and Variety

To give your painting harmony, choose objects starting with a theme in mind, such as a color repeated in various shades, a central idea like gardening, or a collection of dolls. Use complementary colors (see pages 40–41) to enhance color harmony, noting how colors are reflected into adjacent objects.

On the other hand, contrasting objects of various colors, shapes, values, sizes and textures add drama to your painting. An unexpected addition makes your still life more believable, intimate and intriguing: something broken or stained, a shriveled leaf, a brown spot on your apple, a wilted flower or a petal dropped onto the table.

Negative Shapes and Value Shapes

Negative spaces and values (lights and darks) are also shapes. The negative space is the area in the artwork not occupied by the actual subject matter, but still used by the artist as part of the design. Negative spaces and values are just as important to your composition as the objects themselves, and must also have a balance of variety and harmony.

Overlap your objects, or vary the width of the negative spaces between them. Avoid shapes just barely touching each other, which adds undesirable tension.

As you arrange your still life, try not to think of the items as separate shapes, but as values. Similar values can be grouped together and painted as one large, dominant shape. Placing your darkest and lightest values against each other exaggerates their impact. A design using strong values of dark and light, as well as a broad range of in-between values, lifts your painting above the mediocre.

Focal Point

Decide on your focal point, or center of interest. This could be the brightest or most active area, the biggest object or the piece that first inspired you to begin the setup. See if you can get your darkest value in front of or behind your lightest value and make that area your focal point.

You don't want your center of interest to fall right in the middle of your arrangement. A composition that's too symmetrical can be boring. Nor do you want the focal point to end up too close to the sides or corners of your paper. Divide your rectangle with four lines, like a tic-tac-toe grid. Make sure your focal point is not in the middle of any of the boxes, as that would place it precariously close to the edge of the paper or dead center. Ideally, part of it will rest on one of the four crosshatches formed.

Fabric as Stage
Use fabric or tapestry as a flexible stage for your objects. Arrange a fold to direct the eye, or echo the color of objects into the shadows on your cloth.

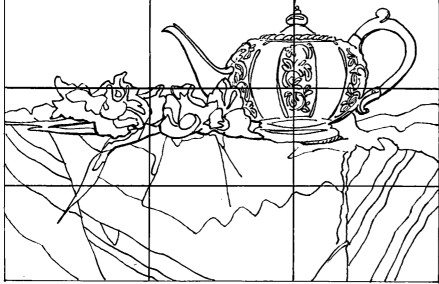

Carefully Considered Composition
In this drawing of *Teapot With Gladiola*, the focal point rests on crosshatches at upper right. Directional diagonals of the cloth and gladiolus leaf keep the teapot anchored on the page, and direct the eye to the focal point.

Set the Stage

Note the activity in various areas of your painting. You want quiet areas (large expanses of cloth, big objects with nonreflecting surfaces, backgrounds without much activity) to set the stage for the action (those areas of bright color, fine detail or complicated reflections around the focal point). Think of the directional movement of your shapes and have them lead the eye toward your focal point. Try to break up any lines running parallel to the sides of the paper.

Complementary Colors
Complementary colors are those directly opposite each other on the color wheel, such as yellow and purple, red and green, blue and orange.

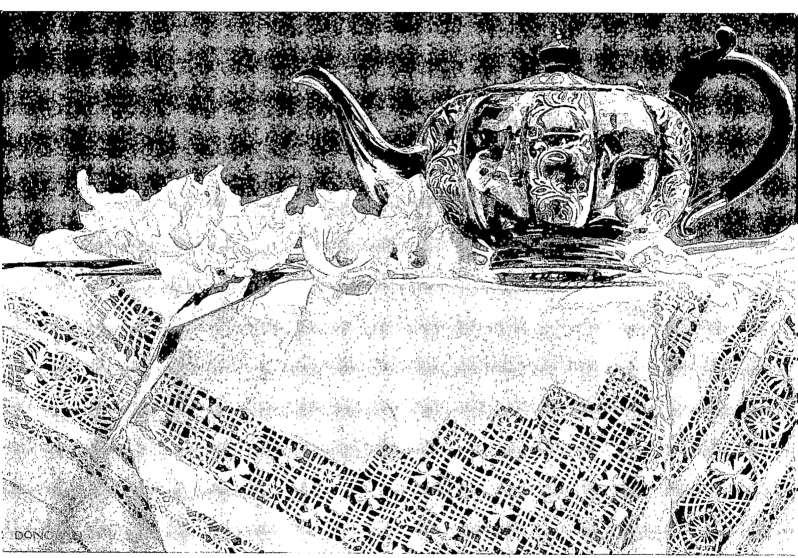

Harmony and Variety
The focal point in this painting is the heaviest, darkest and largest shape—the teapot. Everything else is light and translucent. I gave the background a purple cast to complement the yellow gladiolus.

TEAPOT WITH GLADIOLA, 10½"×16"
(27cm×41cm)
Collection of Hammonda Taylor Osgood.

Interesting Still Life Elements

Focal Point
Although busy with activity and bright colors, this painting's focal point is obviously the large red daisy in the upper right quadrant. Swirling leaves and cloth patterns keep eyes directed into the painting.

GERBERA DAISIES, 25½" × 34½" (65cm × 88cm)
Collection of Kenneth R. Woodcock.

Variety Is Dynamic
Well-known landscape painter John F. Carlson wrote in his book, *Carlson's Guide to Landscape Painting,* "It has been said that nothing depresses the soul so much as perfect symmetry. Symmetry is static; variety is dynamic."

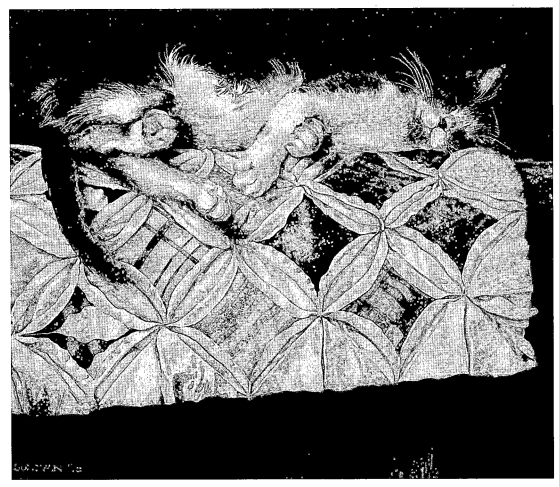

Dramatic Value Contrasts

Intense reds in the quilt pattern are gathered under the cat's face to emphasize its importance as the focal point, while a dark background dramatically contrasts with the bright subject matter.

CAT ON A QUILT,
19"×21"
(48cm×53cm)
Private collection.

Diagonals Direct the Eye

Diagonal quilt pattern lines lead up to the cat's face, which is the center of interest. Paws and tail lead the eye down, helping to anchor the cat, who is precariously near the top of the picture.

> **Values**
> The lights and darks in a picture.

Eye Level

Once you're satisfied with how the elements of your painting relate to one another, choose your eye level. Looking through a viewfinder, such as that on a camera, will help you decide.

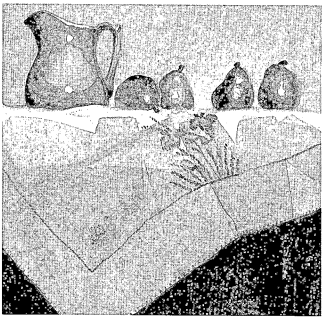

Looking Up
An eye level that looks up at a setup can be quite successful. This view gives the arrangement dominance and importance because it "humbles" the viewer.

Looking Straight On
A straight-on view of your setup flattens perspective, giving the outlines of shapes even more importance.

Looking Down
Looking down adds depth, allowing use of cast shadows to integrate the objects.

Bird's-Eye View
A bird's-eye view has been used successfully by many artists for unusual, exciting compositions. This perspective allows good use of table-covering patterns, objects and cast shadows as elements of the design.

Cropping and Enlarging
Cropping and/or enlarging the image can create interesting negative and positive shapes.

Negative Space
The space in an artwork not occupied by subject matter but utilized by the artist as part of the design.

Guidelines for Good Composition

See if your arrangement meets the requirements of an interesting and successful painting.

- A theme has been established.
- Color harmony has been anticipated.
- There are a variety of colors, shapes, values, sizes and textures.
- Objects overlap or have varying widths of negative space between them.
- There are a good range of well-designed values.
- The focal point, or center of interest, is in a pleasing area of the rectangle.
- Quiet areas and directional movement of shapes enhance the focal point.
- Eye level has been considered.

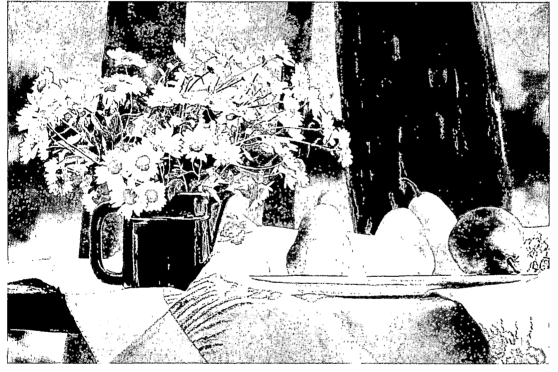

YELLOW PEARS, 20½" × 29½" (52cm × 75cm)
Collection of Mr. and Mrs. LeRoy Wheeler.

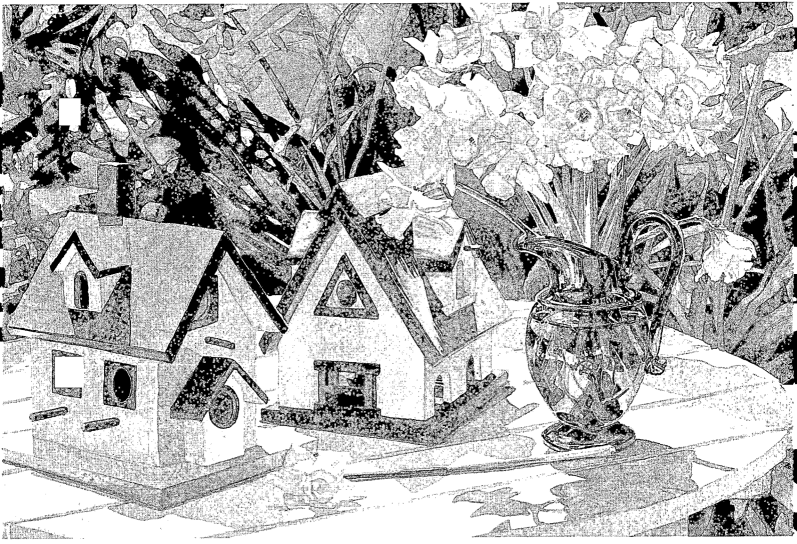

BIRD HOUSES, 20″ × 30″ (51cm × 76cm)
Collection of the artist.

Preliminary Drawing Method

As a beginning art student I found drawing figures and still life frustrating and challenging. I could never get the proportions to look right. The teacups and flowerpots in my work ended up with a peculiarly elongated look and placing them on the paper in a pleasing design took much erasing and rearranging. Some of this I blame on my nearsightedness and an astigmatism, but mostly it was inexperience. Later I saw some of watercolorist Carolyn Brady's beautiful still lifes and after a little research on her techniques, discovered she mounted negatives of her photographs into slide sleeves and projected her images onto watercolor paper, tricks she had learned as a textile designer. I began projecting my photographic images onto paper as part of a preliminary drawing method, to eliminate distortions and gain control over complex subject matter. This makes it easier to deal with light patterns, reflective surfaces and other complicated drawing problems.

If you use prints instead of slides, mount the negative in a blank slide sleeve. Project your slide positive or print negative onto vellum graph paper with a blue fade-out grid taped to the wall (paper can be found in architectural and engineering supply stores). I use a thirty-six-inch wide roll imprinted with a ⅛-inch grid. Trace only the lines you'll need to find your way in the painting.

The camera distortions now have to be corrected, but don't be alarmed. You don't have to make precision drawings. Just check and tidy up perspective and details in your drawing. This is where the graph paper comes in handy. I draw a perpendicular line through the middle of anything symmetrical, plotting the sides with dots on the blue grid to make sure the sides are equal. I also deal with ellipse problems (see page 25).

When satisfied with my drawing, I transfer the image to 300-lb (640gm/m²) cold-press (medium to rough texture) watercolor paper. I like to use 300-lb (640gm/m²) paper because it doesn't need to be stretched; it doesn't buckle and wrinkle with humidity changes once the painting is matted and framed; and its surface can be scraped without putting a hole in the paper. I place a piece of graphite transfer paper, graphite side down, over the watercolor paper. Then, with my drawing over the graphite paper, I trace it. The graphite from the transfer paper can later be erased.

Photographic images can't convey the three-dimensional quality you want in your painting. They flatten the perspective and present everything as equally important. You need to make adjustments to portray what the eye sees.

Setup Reference Slide
I projected this slide to make the preliminary drawing for *Yellow Daylily*. The teapot is distorted and needs to be redrawn, but the detail in the lace cloth is clear enough to enable drawing from the slide, which saved much time in reproducing the complicated pattern. This arrangement is set up outdoors on an ironing board, with Foamcore board placed behind everything.

Photo Equipment
A 35mm camera, tripod and cable release are essential for capturing the information you need on film, even though the photographs you take don't have to be professional. They only need to include light patterns, shadows and other information too fleeting to work from in your setup. You can work with color slide or print film. Take shots at different exposures, along with some close-ups, so you have a complete record of your arrangement.

A Means to an End
• For painting purposes it's better to learn the proportion of form versus the proportion of line.
• Slide projection can help you learn about shape, form and value and finish paintings while learning.
• Don't copy photographs in a paint-by-number manner. With some background in perspective and composition, you can solve problems in the viewfinder of a camera. This saves time and gives you confidence to attempt difficult subjects.

Preliminary Drawing

The blue grid paper I used made it easy to draw a perpendicular line through the middle of the teapot and plot the symmetrical curves of the sides.

It's the Law

If you plan to use slides or photographs as a tool, take your own pictures. Not only is painting from other artists' work or photographs without written permission against copyright laws, but most art shows disqualify paintings if they are aware the artist worked from some resource not their own.

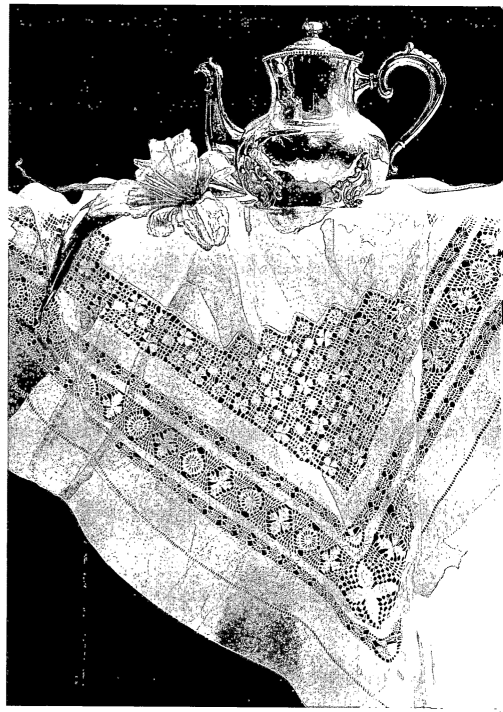

Final Painting

The yellow daylily is the focal point in this picture because it is the only pure color in an otherwise neutral arrangement. Notice how the direction of the cloth folds and pattern direct your attention.

YELLOW DAYLILY, 24" × 17¾" (61cm × 45cm) Private collection.

Preliminary Drawing Method

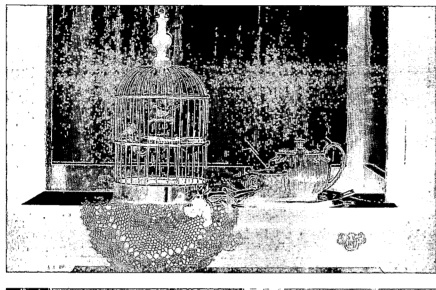

Using Color Negatives
This negative was mounted in a slide mount and projected. It gave me enough information to draw the intricate bird cage, lace cloth and teapot patterns in my painting. I then used a positive photograph and the objects themselves to finish.

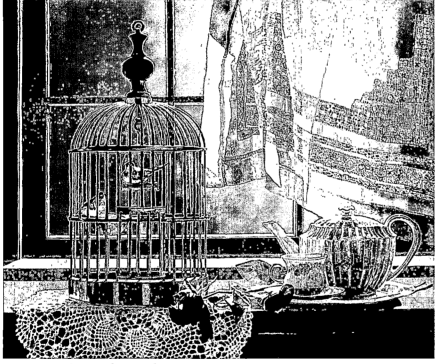

Improvisation and Actuality
The same lace cloth used for many of my paintings served as a curtain here, and I improvised a window with mullions. The sliver of light that is the windowsill running through the bottom of the painting keeps all the objects together, and the backlighting causes everything in the foreground to appear as one darkish value.

BIRD CAGE WITH ROSE, 24" × 29" (61 cm × 74 cm)
Private collection.

How We See
It has been suggested that the elongated figures of El Greco (1541-1614) resulted from an astigmatism that affected the way he saw things. While some would argue his unique vision was his gift, it's likely his paintings would have a very different look if he had used modern photographic equipment. On the other hand, when well-meaning people tell me a painting looks "just like a photograph," I'm always disappointed. I want my paintings to look the way we really see things; the eye does not see every flat detail the way the camera records it. The eye sees objects in space, with all their form, as well as the color changes atmospheric perspective brings.

The Mysterious Ellipse

A circle that's parallel to the ground, like a plate or the mouth of a glass, appears as a straight line at eye level. It opens into an ellipse (oval) as it gets farther below or above eye level. Such ellipses sometimes present a unique perspective problem. All ellipses have a major axis and a minor axis. Where these meet at the center of the ellipse, four right angles are formed, resulting in four equal quadrants. But the center of a circle drawn in perspective doesn't lie on its ellipse's major axis; it's further from the viewer. To fix the position of the center, a foreshortened square is drawn in one-point (with its sides receding to one vanishing point on the horizon) perspective around the ellipse. Diagonals connecting the corners intersect at the real center.

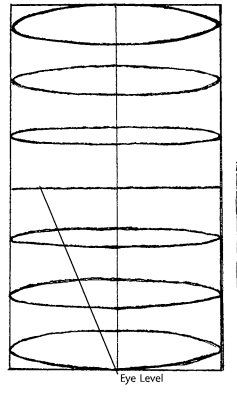

Eye Level

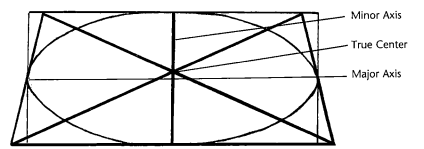

Minor Axis

True Center

Major Axis

How Water Behaves
In reality, the surface of still water is always level, that is, parallel with the horizon line. Don't let your water roll downhill unless it's being poured.

Know Simple Perspective
Become familiar with simple perspective; there are books devoted entirely to this subject.

Adding Sparkling Sunlight

Sunlight is a wonderful tool to add bold contrasts, luminous shadows and mood-elevating, high-key colors to your still lifes. Where the sun rests on objects, it appears to bleach them near white. Where it passes through transparent things, like a flower petal, a leaf or colored glass, it brings out intense, jewel-like color saturation. Sunlight will bounce reflected color all over your still life. Intriguing patterns are created by cast shadows of arrangements.

Lighting Your Subject With Sunlight

Set up your still life to take advantage of available sunlight. A window as your light source can result in dramatic effects in winter, when days are short during the months before and after the winter solstice. Sunlight streams into windows casting long shadows from the sun's low placement in the sky. This is especially true if you live in a cold climate with no leaves on the trees to filter out the weaker winter sun. Colored glass on a windowsill produces vivid colors and reflections.

If you have trouble getting enough light on your subject, take the setup outside. I sometimes place formal arrangements outdoors on an ironing board; then I can turn them in any direction to catch the light and adjust up and down for the right eye level (see pages 18–19, *Yellow Daylily*). Placing a board in back of the setup covers distracting backgrounds. You'll be amazed how quickly the light changes as you arrange your shapes. Indoors you can set up one day and photograph the next if the changing light has left by the time you are ready to shoot.

Orchestrating the light and shadow of your still life is a matter of turning, raising and lowering the arrangement to catch the sun from different angles. Experiment until you're satisfied with the result. Observe the effects of the different angles of the sun in the examples on the next page.

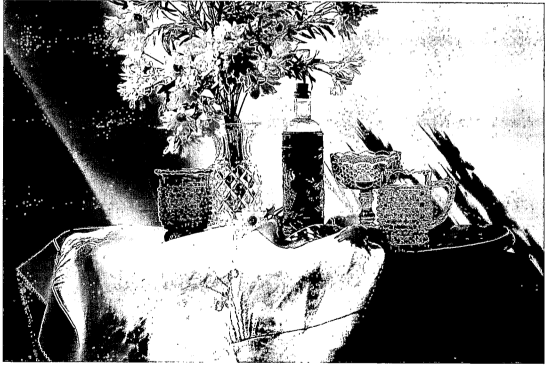

Three-Quarter Light
The sunlight on this arrangement has been aimed at a three-quarter angle that accents the forms of the objects and the cloth. Long shadows are cast against the backdrop, while the table in shadow appears very dark.

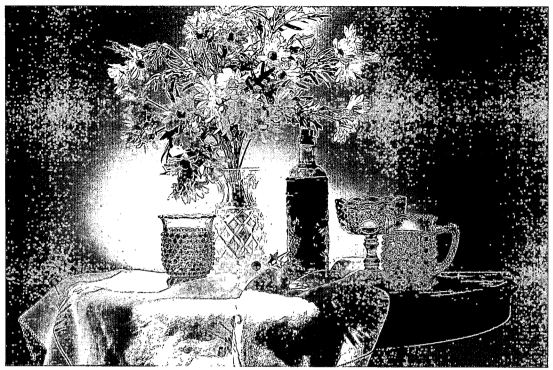

Side Light
An interesting effect is achieved by light coming from above at an angle that spot-
lights the setup on one side; shadows play over the flat surfaces, unifying the value
patterns.

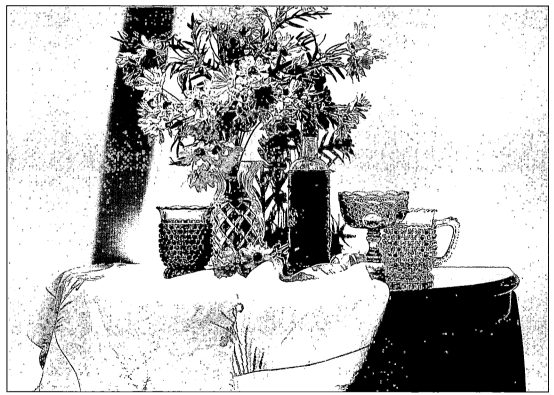

Front Light
Some modeling of forms and interest is lost with front lighting; look at how flat the
cloth appears, and how its shadows are barely visible; the objects no longer cast
much of a shadow either. In this case, it is the most uninteresting of lighting choices.

Backlighting

Light from behind your still life brings out strong color saturation in the transparent objects and haloes of light around the opaque ones. The outline of your composition becomes more important as your arrangement appears as a near silhouette. Areas not in the light will have closely related values. Flowers and plants have a translucency that is especially revealed with backlighting.

Backlighting
Here I have placed the arrangement with its back to a glass door, which creates a confusing background. Yet the color saturation of the colored glass as the sunlight passes through it is dramatic, and strong patterns of light on the tabletop contrast with the cloth in dark shadow in the foreground. The glass objects have haloes of light and cast colorful shadows.

In the final painting, the background is simplified and the foreground is darkened to make the light areas stand out.

WINDOW GLASS,
20″ × 21″
(51cm × 53cm)
Collection of Drs. John and Barbara Rock.

Reflected Light

Look for colored light bouncing into the shadows of your sunlit arrangements; this reflected light will be lighter than the shadow, but darker than the sunstruck areas. Reflected light adds luminosity and also helps model form.

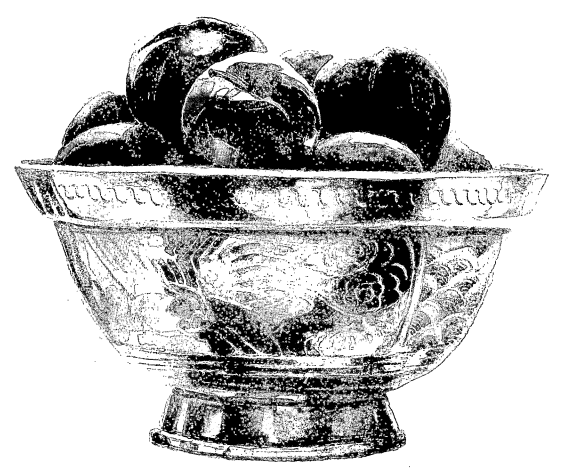

Reflected Light
The sun shining behind a brass bowl of plums casts rims of light around them; reflected light bounces up onto the bowl from a sunlit table surface. This reflected light is never as light as direct sunlight, even though the local color of the brass is lighter than the dark purple plums.

Backgrounds

Plan backgrounds as carefully as your arrangement. The shapes and colors of the background are important to your composition. Negative and positive shapes in the background need to be in harmony with their adjoining foreground shapes. If the colors are cooler and grayer in the background, they will recede and help your arrangement come forward.

Be inventive with your backgrounds but don't let them compete too much with your setup. Accent a color in the foreground with a grayed complement. Place a smooth or shiny object against a rough or textured background and the contrast will emphasize its surface characteristics. Darkened room interiors behind a sunlit arrangement can provide dramatic contrast. Here are some examples of backgrounds I have used in my paintings.

A Simple Background
"The simpler a background is, the more mastery there must be in it." This quote by Robert Henri (1865-1929), an American painter and teacher who wrote *The Art Spirit*, is certainly true of watercolor still lifes. Anyone who has ever tried to lay in a large, smooth graded wash of color knows how many things can go wrong.

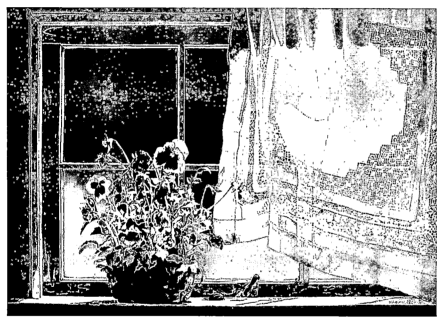

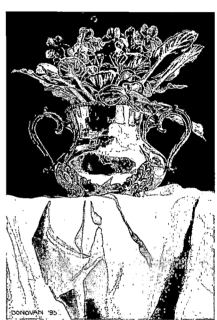

Windows
A window has all kinds of possibilities as a backdrop, such as for backlighting, as used here. A dark cloud accents the white pansy, and the curtain catches sunlight filtering through the clouds. In the painting *Brass Bucket of Cattleya*, on page 140, I have placed the still life outside in front of a window that acts as a dark but reflective background. The mullions of the window provide a gridlike framework for objects.

PANSIES, 23" × 30" (58cm × 76cm)
Private collection.

Dark Background
A dark background gives a dramatic accent that really sets up the whites and colors. It's also a good solution for covering up a ruined background.

AFRICAN VIOLETS,
14¾" × 10½" (37cm × 27cm)
Collection of John Freeman.

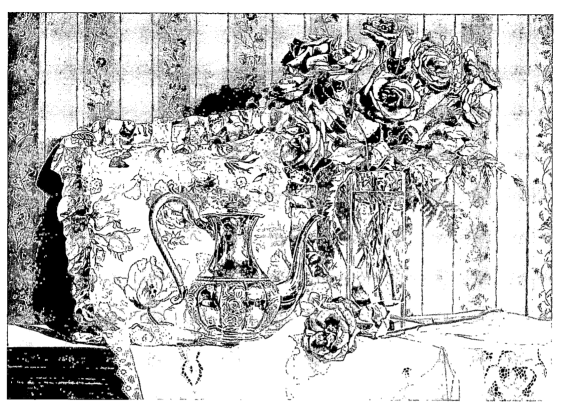

Patterns

Wallpaper, fabric, tapestry and curtains can all be used as backdrops. A neutral wash will tone them down, keeping them in the background where they belong.

PINK ROSES,
30" × 38"
(76cm × 97cm)
Private collection.

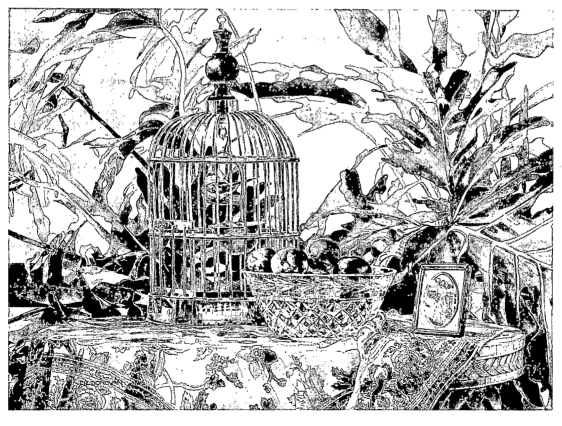

Foliage

I have a huge philodendron I use in the background of many paintings. The large leaves and stems can direct the eye, and the cool green color complements hot reds and pinks in warm sunlight.

BIRD CAGE AND
BOWL OF PLUMS,
22" × 30"
(56cm × 76cm)
Collection of the artist.

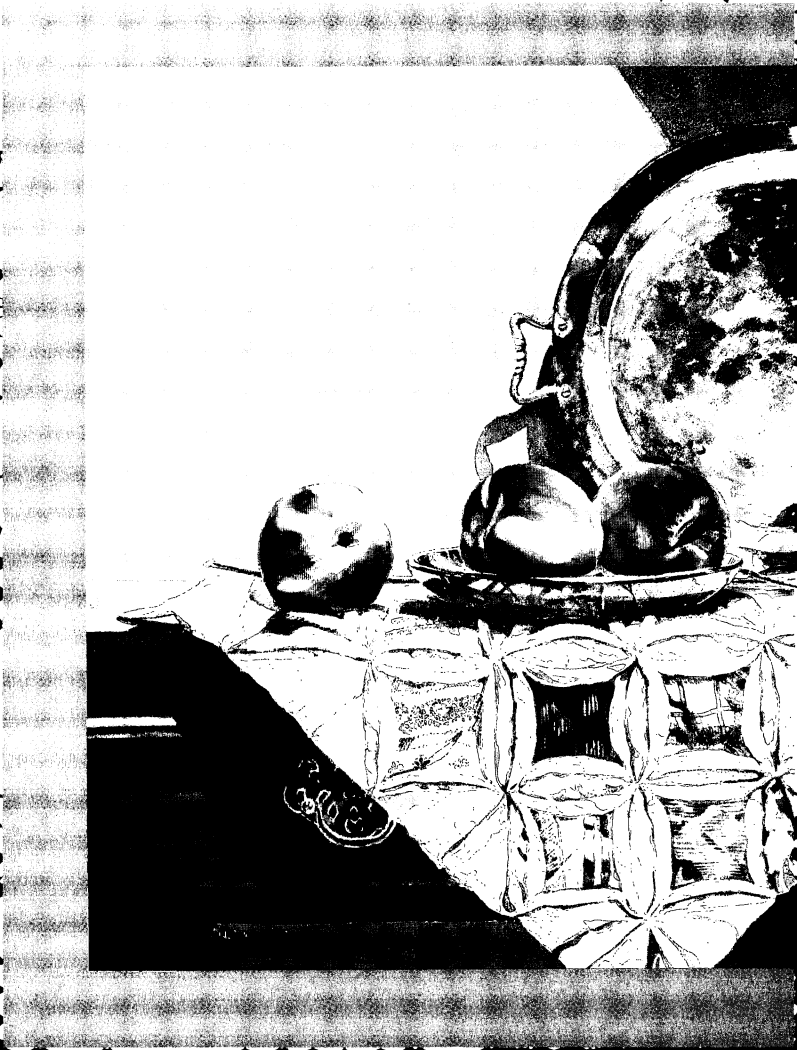

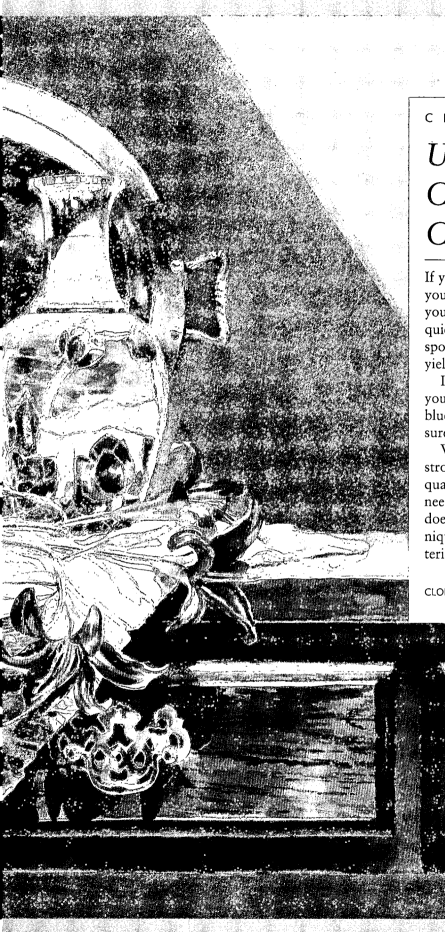

Using Materials, Colors and Values Creatively

If you are a beginning painter don't confuse yourself with too many materials. By limiting your brushes and paints at first you will quickly become familiar with how they respond. You need materials you can depend on, yielding a consistent result with no surprises.

It is also helpful to limit colors. Really, all you need in watercolor is a red, a yellow and a blue. Choose these three colors carefully to be sure they will harmonize with one another.

When it comes to paper and paint, I strongly recommend the best "artist's grade" quality. Even a beginning watercolor student needs to experience what good quality paint does on good paper before perfecting technique. What follows is a description of the materials I used to do the paintings in this book.

CLOISSONÉ VASE, 19" × 25¾" (48cm × 65cm)

Materials and Supplies

Brushes

Good brushes, whether synthetic, ox hair or sable, hold their shape while wet. Most art stores have a cup of water on hand so you can test this quality. Rinse the sizing from the brush and flick the excess water out. The brush should hold its shape and appear full toward the ferrule, the metal part of the brush that holds the hair or bristles. Gently press the side of the bristles onto a piece of paper or the palm of your hand. When lifted, the brush should return to its original shape, with a point if it is round and a chiseled edge if it is flat. If bristles droop or remain separated, the brush is not satisfactory. I'm always buying new brushes, but I usually end up using a few favorites:

- 1½-inch (38mm) flat wash brush
- 1-inch (25mm), ¾-inch (19mm) and ½-inch (12mm) flat brushes
- no. 14, no. 10 and no. 5 round brushes
- no. 4 rigger for fine lines

The Incredible Nib

This tool has a wedge-shaped nib at one end and a sharpened point at the other. When dampened, it softens edges. I also use it as a drawing tool in darker, wet washes, or to wipe away unwanted passages. It provides control in correcting, blending and softening.

Arches 300-lb (640gm/m²) Cold-Press Watercolor Paper

This paper has a warm white cast that lends itself to sunlit whites.

You don't need to stretch it, it doesn't buckle with humidity changes once it is matted and framed; and you can scrape the surface quite a bit without making a hole in the paper. The texture helps give brushstrokes a rough, painterly quality. It does matter what side you use. The wrong side accepts paint differently and has a more regular, pebbly grain. Hold the paper up to the light and make sure the Arches watermark reads forward. I prefer to paint with the sizing still there as the paint is not absorbed as readily.

Azon Trazon Blue Grid Paper

Described on page 22, this vellum graph paper with blue fade-out grid, is available at architectural and engineering supply stores in thirty-six-inch wide rolls.

Sally's Artists' Graphite Paper

Use this graphite-coated paper like carbon paper to transfer-trace a design to another surface. I get this in a box of twelve 18″×24″ reusable sheets. When transferring a larger drawing, just move the graphite paper as you draw.

Pebeo Liquid Frisket

This is my frisket of choice. So thin it was made to be used in an airbrush, it can be diluted with water. Have a few inexpensive brushes set aside for frisket only, as it is devilish to remove.

Craft Knife and Razor Blades

Use these to recover white paper. After you have scraped the paper it no longer accepts further layers of paint without dark lumps and bumps showing up, so only use these as a last step.

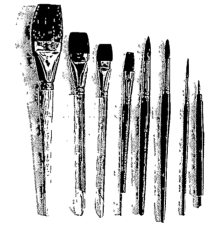

(1) 1½-inch (38mm) wash brush, (2) 1-inch (25mm) flat brush, (3) ¾-inch (19mm) flat brush, (4) ½-inch (12mm) flat brush, (5) no. 14 round brush, (6) no. 10 round brush, (7) no. 4 rigger, (8) The Incredible Nib.

Dr. Ph Martin's Bleed Proof White

This is for emergencies, when you can't scrape in a highlight or the white of the paper is no longer retrievable.

Distilled Water

Whenever possible, I use distilled water instead of tap water, which leaves a faint mineral salt deposit. Notice the spots on a water glass after tap water has dried. These deposits will dull your colors, eventually staining and discoloring even archival paper. But if using distilled water means you'll be tempted not to change to clean water as often, disregard this recommendation.

Slide Projector

I use a slide projector for both drawing purposes and slide viewing.

35mm Camera, Cable Release and Tripod

A 35mm, camera, tripod and cable release are essential for capturing the information you need. The cable release and tripod are useful with longer exposures to prevent movement that causes fuzzy photographs and slides.

Purity of Watercolor

The purity of transparent watercolor is maintained more than any other medium because only water is used to dilute the pigment.

Sally's Artists' Graphite Paper

From left to right, this photo shows a craft knife, razor blade, Dr. Ph Martin Bleed Proof White and Pebeo liquid frisket.

Arranging Your Palette

Capturing the bright colors of sunlit arrangements requires high-key, saturated (pure, intense) colors. I use the John Pike Big Well Palette to arrange my paints, putting the yellows and reds along one side. Opposite them are placed greens and blues that can be dragged out and mixed easily. Keeping complementary colors far away from one another helps maintain their purity, because adjoining colors bleed into each other. Unsaturated colors, such as Raw Sienna and Burnt Sienna that are more neutral go at the bottom of the palette. Keeping your colors in the same place on your palette makes locating and identifying them much easier.

Conserving Paint

The colors I use most, Rose Madder Genuine, Aureolin Yellow and Cobalt Blue, are all series 4 Winsor & Newton colors, which means they are expensive. When a tube is used up I cut it lengthwise, spread it open and put it in a container of distilled water. Margarine tubs are good for this. After the tube has soaked clean I remove it and I'm left with a tub of thin wash for glazing or mixing.

The Colors

The watercolors on my palette are all Winsor & Newton, except for Sennelier's Viridian. Winsor & Newton's Viridian is drier and harder to work with. I also have a large collection of violets and roses for painting brilliant flower colors when mixed color just doesn't do, for example, LeFranc & Bourgeois Linel's Ruby Red on page 73.

Yellows
Aureolin Yellow—cool, transparent, delicate, mixes well without overpowering other colors.

Cadmium Lemon—cool, opaque, brilliant.

Cadmium Yellow—warm, opaque, brilliant, mixes with Cadmium Red for a bright orange.

New Gamboge—warm, transparent, intense.

Yellow Ochre—cool, semitransparent, unsaturated (grayed), I keep this at the top of the yellow column to distinguish it from Raw Sienna.

Raw Sienna—warm, transparent, unsaturated, brighter than Yellow Ochre.

Reds
Alizarin Crimson—cool, transparent, staining.

Cadmium Red Medium—warm, opaque, brilliant.

Rose Madder Genuine—cool, transparent, delicate.

Indian Red—cool, violet-red, opaque, unsaturated earth color.

Light Red—warm, orange-red, semi-opaque, unsaturated earth color.

Violet
Winsor Violet—warm, transparent, I keep this on my palette to modify yellows.

Blues
Cerulean Blue—somewhat cool, opaque.

Cobalt Blue—warm, semitransparent, delicate, mixes well without overpowering.

Ultramarine Blue—warm, semitransparent, brilliant, mixed with Burnt Sienna it makes an attractive grainy neutral.

Winsor Blue—cool, transparent, intense, staining, a little goes a long way.

Greens
Viridian—cool, transparent, delicate.

Winsor Green—cool, transparent, intense, staining, use sparingly.

Browns
Burnt Sienna—warm, transparent, an unsaturated orange, perfect for rust.

Burnt Umber—cooler than Burnt Sienna, transparent.

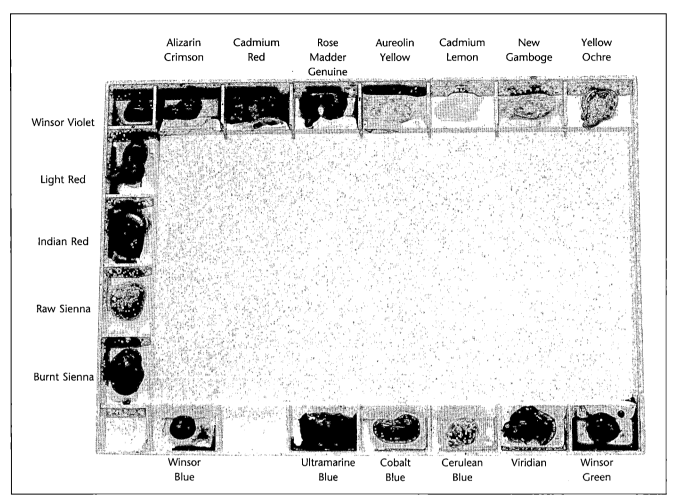

	Alizarin Crimson	Cadmium Red	Rose Madder Genuine	Aureolin Yellow	Cadmium Lemon	New Gamboge	Yellow Ochre
Winsor Violet							
Light Red							
Indian Red							
Raw Sienna							
Burnt Sienna							
	Winsor Blue		Ultramarine Blue	Cobalt Blue	Cerulean Blue	Viridian	Winsor Green

Palette

Yellows and reds are placed along one side of my palette. Greens and blues are placed along the other side. Unsaturated colors are placed on one side, with the exception of Yellow Ochre, which I put with the yellows because it's difficult to distinguish from Raw Sienna. I keep Winsor Violet in a corner box to use as a modifier for my yellows.

Mixing Darks

You'll notice there are no blacks (black, Payne's Gray, Davy's Gray or Neutral Gray) in my list of colors. Black is the absence of all color or light. Since we're trying to fill our sunlit still lifes with color and light, we'll avoid black. You can get a rich dark by mixing Alizarin Crimson and Winsor Green.

Creating Light and Shadow With Color

Delicate Colors

The delicate colors of Rose Madder Genuine, Aureolin Yellow and Cobalt Blue work well in sun-bleached areas of your painting. They make excellent glazes because they are transparent and won't overpower each other. They can be mixed for the delicate shadows of flower petals and other transparent and semitransparent objects. Nonstaining, they are easily worked or lifted after they dry.

Brilliant, Transparent Colors

Alizarin Crimson, New Gamboge and Winsor Blue are the intense primary colors on your palette. They can quickly overpower a painting and need to be tamed with complements. They are appropriate as strong accent colors and should be used sparingly. These rich darks and bright transparent yellow will yield a full range of values. The most staining triad of colors, you must plan ahead when using them.

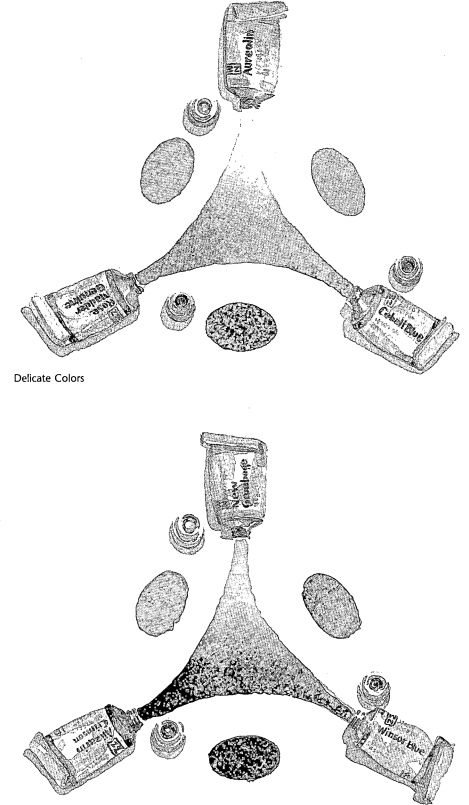

Delicate Colors

Brilliant Transparent Colors

Opaque Colors

Light Red, Yellow Ochre and Cerulean Blue are dense, heavy pigments that settle into the paper leaving interesting textures. More than one opaque in a color mixture dulls and deadens. They do describe some surfaces in your still life perfectly, though.

Avoid Muddy Color
- Don't mix more than three colors.
- Don't use more than one opaque color in a mixture.
- Don't overmix your colors.
- Don't use an equal amount of each color or they will cancel each other out.

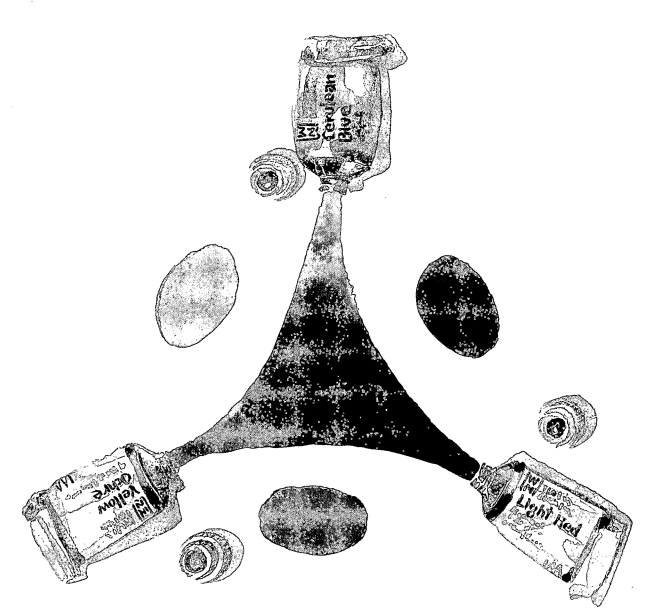

Opaque Colors

Complementary Colors

Referring to the color wheel is not necessary when explaining complementary colors. The complement of a primary color (red, yellow or blue) is simply the remaining two primary colors mixed together. The complement of red is blue and yellow mixed together, or green. The complement of blue is red and yellow mixed, or orange. The complement of yellow is blue and red mixed together, or purple.

You will modify (usually by graying) most of the colors by mixing them with others from your palette. Using too many colors straight from the tube can produce a neon look. Mixing a color with a little of its complement grays its intensity but maintains its identity. Achieving luminosity in your grays requires choosing complements for your colors that are compatible.

Useful Mixtures of Complements

Beautiful Granular Effects
The sedimentary quality of Burnt Sienna and Ultramarine Blue causes the pigments to settle into the valleys of the paper for beautiful granular effects.

Intense Blacks
A mixture of Alizarin Crimson and Winsor Green will yield intense blacks leaning toward red or green.

> **Enhance a Color**
> Complementary colors can be used to enhance a color if, instead of being mixed with the color, it is placed near it.

Gentle Grays

Mixing Rose Madder Genuine and Viridian will give you gentle grays but no strong darks.

Beautiful Brown Grays

Beautiful brown grays are achieved when Winsor Violet is used to modify its complement, yellow. Glazing with Winsor Violet is another way to tone down a bright yellow.

Raw Sienna and Cobalt Blue

Raw Sienna is one of the brighter unsaturated colors; it can be mixed with Cobalt Blue for an interesting orange or blue gray.

Don't Overmix

Don't overmix your neutral colors. Push the mixture toward one color or the other to ensure it has life and color identity.

Complementary Color in Shadows

Shadows on sunlit objects are warm and transparent. Glaze over thoroughly dry painted objects for shadow effects. The local color of the object will shine through the shadow glaze for a luminous shadow.

Cast shadows of sunlit objects tend to vibrate with the local color of the object casting the shadow. They can also contain the complement of the object casting the shadow. Avoid overmixing your shadows to be sure they have a color identity, rather than appearing gray.

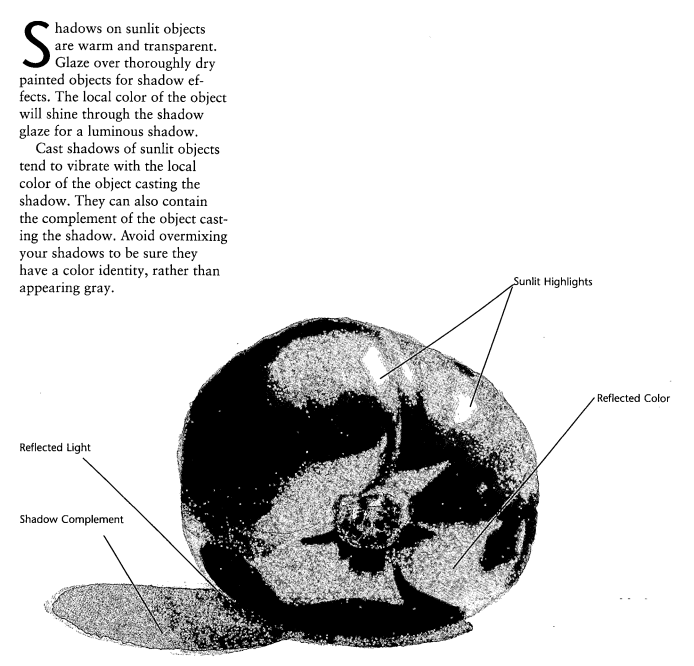

Sunlit Highlights

Reflected Color

Reflected Light

Shadow Complement

Shadows
Shadows of objects often contain both the color of the object casting the shadow and its complementary color. The shadow of the tomato is green, with the reflected light from the tomato adding some red.

The Importance of Values

Painting is, more than anything else, a constant comparison of values. Just as colors look most vivid next to their complements, lights look brightest next to the darkest value. If the highlight is white, how dark must the surrounding color be to make it look shiny? If light is coming in a window, how much darker is the windowsill in shadow than in sunlight?

Make a Value Scale

A value scale will help you answer these and the hundred other questions you will ask yourself as you paint. The standard value scale has ten values from white to black, but you'll do better with a simplified version of five plus white (see illustration).

You can make this scale yourself using a mixture of Alizarin Crimson and Winsor Green. With a paper punch, put a hole in the middle of each value. Hold your value scale over colors to determine their value, or hold it over white to see how a highlight will show up against a value.

Because paint dries lighter than when applied, it's difficult to judge values by sight. If you are working wet-in-wet, the values will dry even lighter.

There are two ways to overcome this problem. Either paint darker than you want the final shade to be, which takes a lot of practice, or start light and glaze layers of paint over each other until the desired value is reached. This takes practice, too, because certain colors don't work well over other colors. Any opaque or yellow color used in your glazing should be used first, because yellows or opaques used over other colors tend to muddy them.

Your light source, the sun, and its reflected light will determine what will register as a light or dark value. Objects that are in actuality white can be in shadow and sometimes appear darker than sunlit things whose local color is much darker.

> ### Using the White of Your Paper
> You are not adding light to your paintings; it is already there in the white of your paper. As you cover areas with transparent watercolor, the white of your paper shines through, giving the illusion of light coming from another source. Other areas will be darkened with opaque color, or many layers of transparent pigment, and the light will be covered.

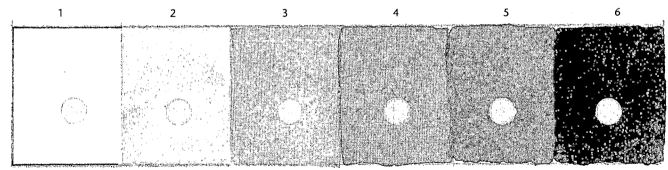

Value Scale
Paint squares of tone with your 1-inch (25mm) flat brush. Paint black on one end using a mixture of Alizarin Crimson and Winsor Green; leave the other end white. Painting the middle tone, then fill in the squares in between. Use a paper punch to put a hole in each value.

A Value Study

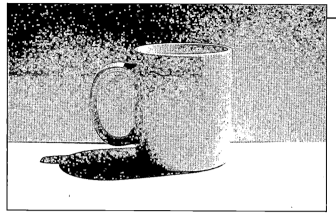

Step One

1 Determine Values

Take a simple white object like this mug and do a value study in sunlight. The two highlights on the lip of the mug are in reality brighter than your paper, and will be your lightest value; you'll need to surround them with darker values to make them read light enough. Holding your value scale up to this subject, you can see that to have the sunlit highlights register, the rest of the mug must be painted at least two values darker.

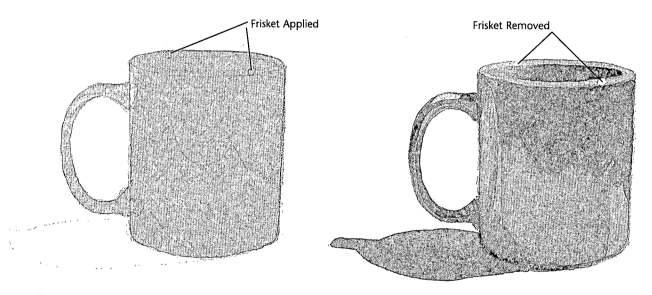

Frisket Applied

Frisket Removed

2 Draw and Save Highlights

Draw the object and then save the highlights with liquid frisket. Paint the entire mug a value three. I used a mixture of Cobalt Blue, Aureolin Yellow and Rose Madder Genuine here.

3 Finish With Shadows

Once you've established your two lightest values, you must go to a value four for the lighter shadows and almost to black for the darkest shadows. Your white object now has a full range of values!

Technique Tip: Applying a Large Wash

Form a Bead or Puddle

To apply a smooth, even wash, have your paper slightly slanted, and keep enough paint along the downside edge of the wash to let gravity form a long bead, or puddle, of wet paint; too much paint and it will drip down. Pull this bead of paint over the entire area to be covered, moving quickly.

Watch for Bloom

If the puddle of paint sits too long on the surface, the thinner area of paint behind it will begin to dry and draw the wet paint back into it causing it to *bloom*.

Avoid Thin Paint Strokes

Avoid thin paint strokes at the edge of your wash, as they will dry quickly and be visible through subsequent strokes.

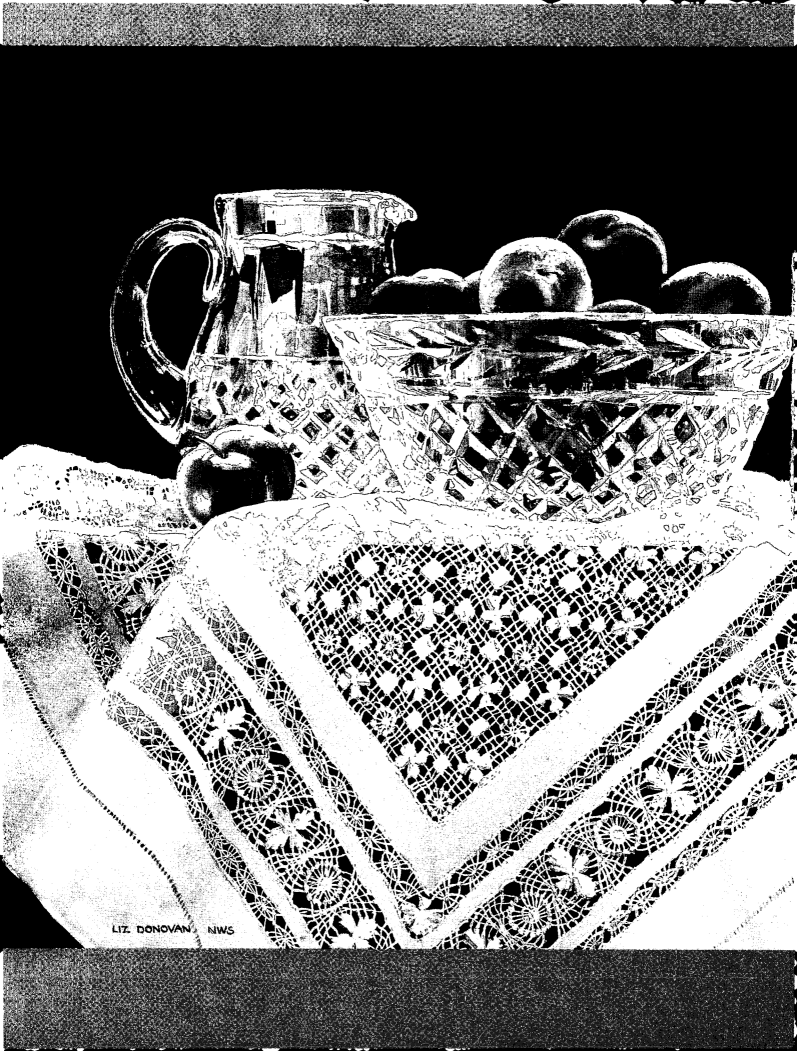

LIZ DONOVAN, NWS

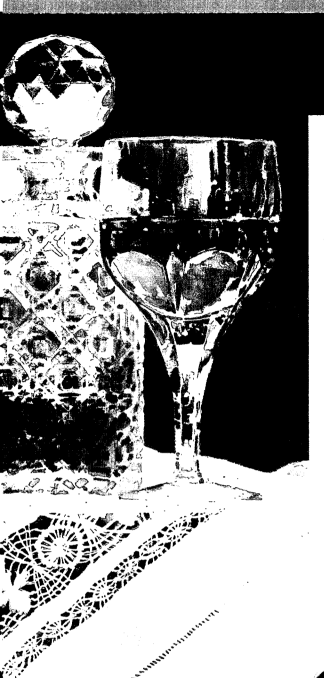

CHAPTER THREE

Painting Beautiful Fabric and Lace

Fabric can play an important roll in your still-life paintings. Use tablecloths with their soft folds to direct the eye into your arrangements and to break up the hard lines of a table edge. You will have more control over the shape and movement of the drapery than of any other element of your setup. Different fabrics have their own unique qualities and hold unlimited challenges for the artist. I have included only a small sample of the fabrics you will encounter as you explore still-life painting, but the approach will usually be the same. Closely observe and make a careful drawing. Paint the basic structure of the folds with warm and cool, and light and dark values and then apply any patterns and colors.

CRYSTAL AND PLUMS, 20¾" × 28¾" (53cm × 73cm)

Lace

The intricate, complicated patterns of lace needn't intimidate the novice painter. Begin with a detailed drawing. Photographing and projecting the pattern will save much time in this case. A few concentrated areas of great detail and then some areas you sketchily wash in are more interesting than each little hole and thread painstakingly painted.

> **Color Palette**
> Cobalt Blue
> Raw Sienna
> Rose Madder
> Genuine

1 Save the Holes

After drawing the crocheted lace pattern save the holes with frisket. This is opposite how frisket is used in the lace demonstration on pages 110-115, *Crystal and Plums*. In that painting the background is dark and the lace pattern more delicate so I masked the lace and painted the holes.

2 Paint the Folds

With the holes saved and the pattern drawn you can be free and loose painting the folds. Raw Sienna modified with a little Cobalt Blue and Rose Madder Genuine makes a good yellowed antique color. Don't mix the colors too well and have a warm-to-cool transition in the folds. Some areas get a pinker look to add color interest.

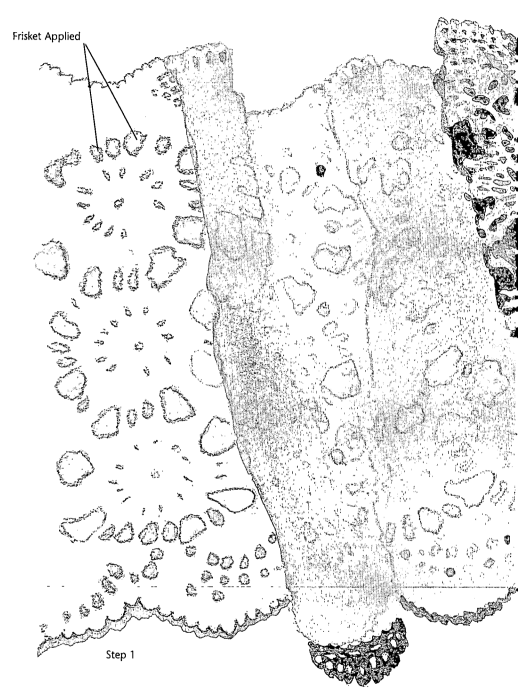

Frisket Applied

Step 1

Step 2

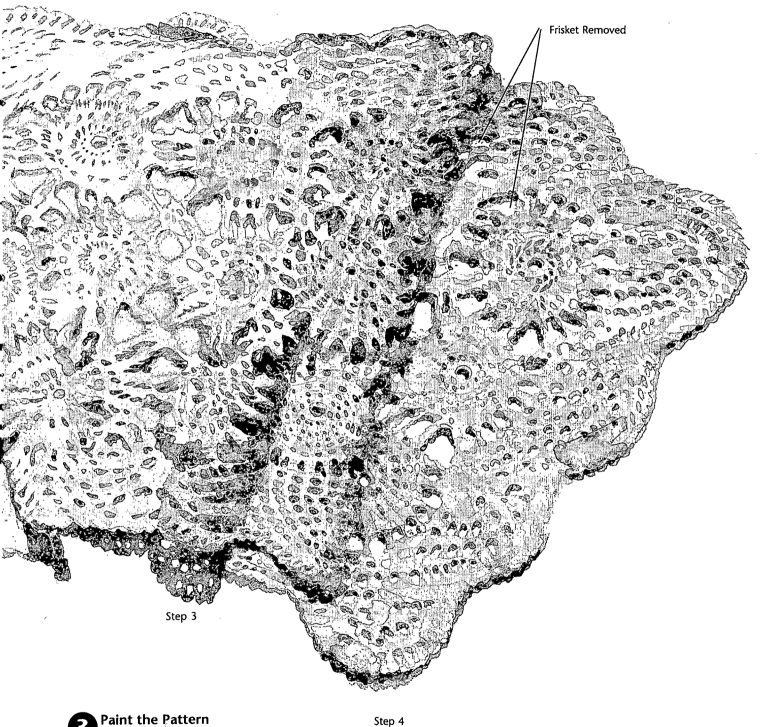

Frisket Removed

Step 3

Step 4

3 Paint the Pattern

As you paint the lace design in more detail avoid painting every hole. Just suggest it in places and let the viewer do some of the work. Small washes that follow rows of stitches help contour the surface.

4 Remove the Frisket

After the frisket is removed, a dark shadow over each hole adds volume to the crocheted effect.

Oriental Rug

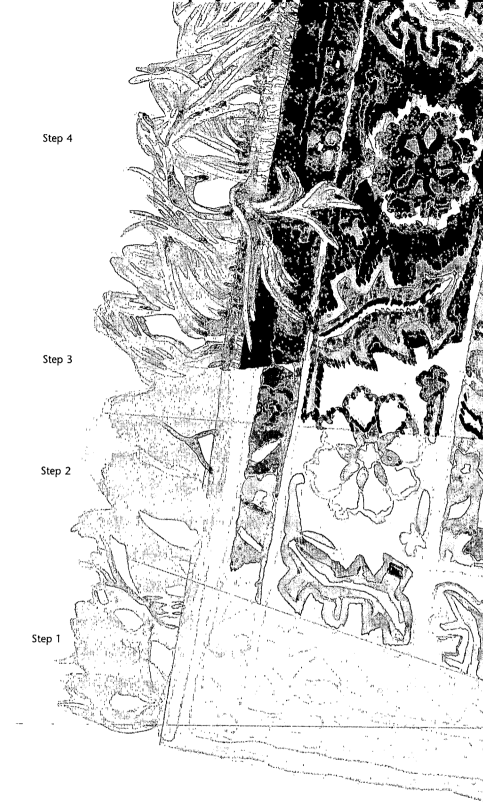

Step 4

Step 3

Step 2

Step 1

The texture of an Oriental rug is thick and soft. Its design is crude and fuzzy. If you were painting this rug in perspective the detail and strong color would appear in the foreground, and as the rug receded the color would be grayed and the pattern would be painted more impressionistically.

Color Palette
Cadmium Red
Cadmium Yellow
Cobalt Blue
Rose Madder Genuine
Ultramarine Blue
Yellow Ochre

1 **Draw the Design**
Draw the rug and block in the design. Get rid of the stark white paper using a wash of Yellow Ochre with a touch of Rose Madder Genuine to give it a pink tinge and Cobalt Blue to gray it down.

2 **Paint the Pale Colors First**
Start with the lightest colors and work up to the dark reds and blacks. I use Yellow Ochre for the gold color, diluted Cadmium Red for the pink and diluted Ultramarine Blue with a little orange (Cadmium Yellow and Cadmium Red) for the blue. These are all fairly opaque colors.

3 **Apply the Outlines**
Use short choppy strokes to brush on the red and blue-black outlines to give them an irregular fuzzy look.

4 **Finish the Larger Areas**
The large areas of red and blue-black are filled in. For the blue-black color I use the same mixture of Ultramarine Blue and orange with very little water.

After everything is dry pull a wet brush over the design in the direction of the weave to break up the whites and suggest more of a nap.

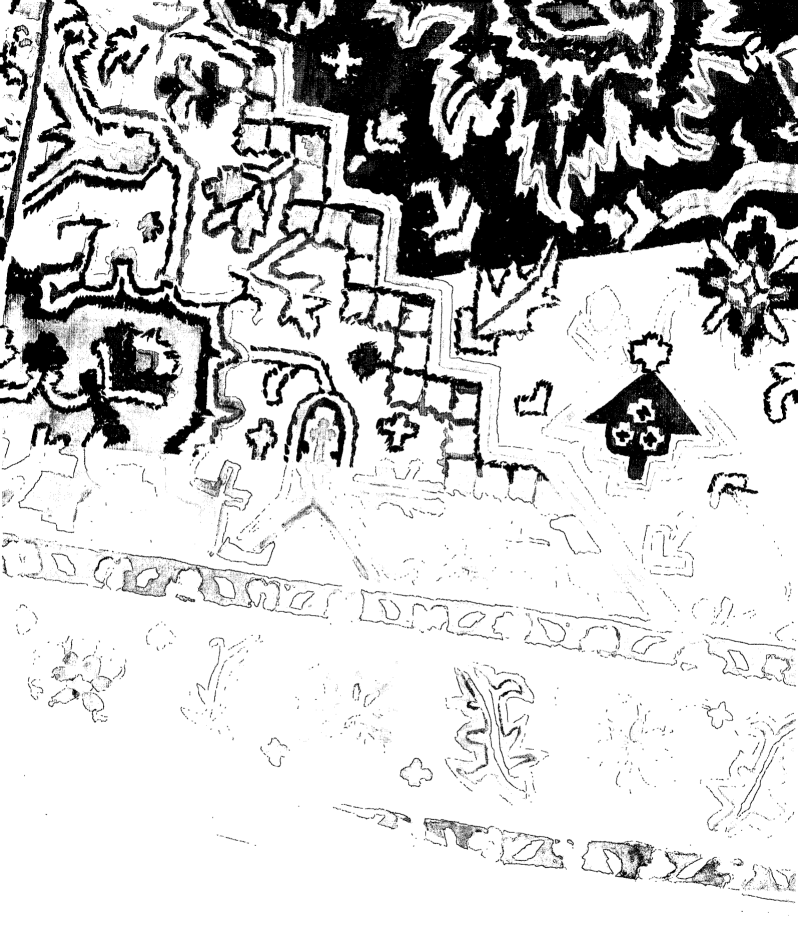

Satin and Velvet

The highlights, shadows and folds are key to describing the weight and texture of a fabric. Shiny fabrics such as satin or silk will have bright highlights and fairly light shadows as reflected light bounces into them. Lightweight fabrics fall into small folds. Heavier fabrics such as velvet or wool have dull highlights, dark shadows and larger folds.

> **Color Palette**
> Alizarin Crimson
> Winsor Blue
> Winsor Green

1 Draw the Fabric
The satin part of this satin and velvet blouse is a highly reflective cloth. When you have drawn the blouse, including the larger folds, cover everything with a light wash of Alizarin Crimson, Winsor Blue and Winsor Green.

2 Paint Soft Shapes
When Step One is almost dry, paint in lots of slightly darker shapes around the light satin wrinkles. The damp underpainting will soften the edges.

3 Add the Darker Areas
Paint the darker areas of the satin using a mixture of Alizarin Crimson, Winsor Blue and a touch of Winsor Green to modify the lavender color. The velvet is also painted using this mixture but solidly. After the velvet application is somewhat dry, pull the dull highlights of the wrinkles out with an almost dry brush. An ink eraser, lightly applied on dry paint, also works.

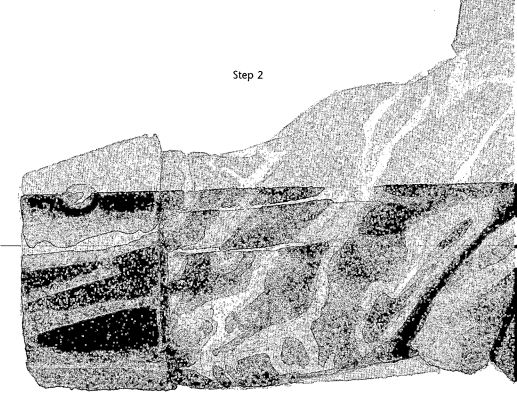

Step 2

Step 3

Step 1

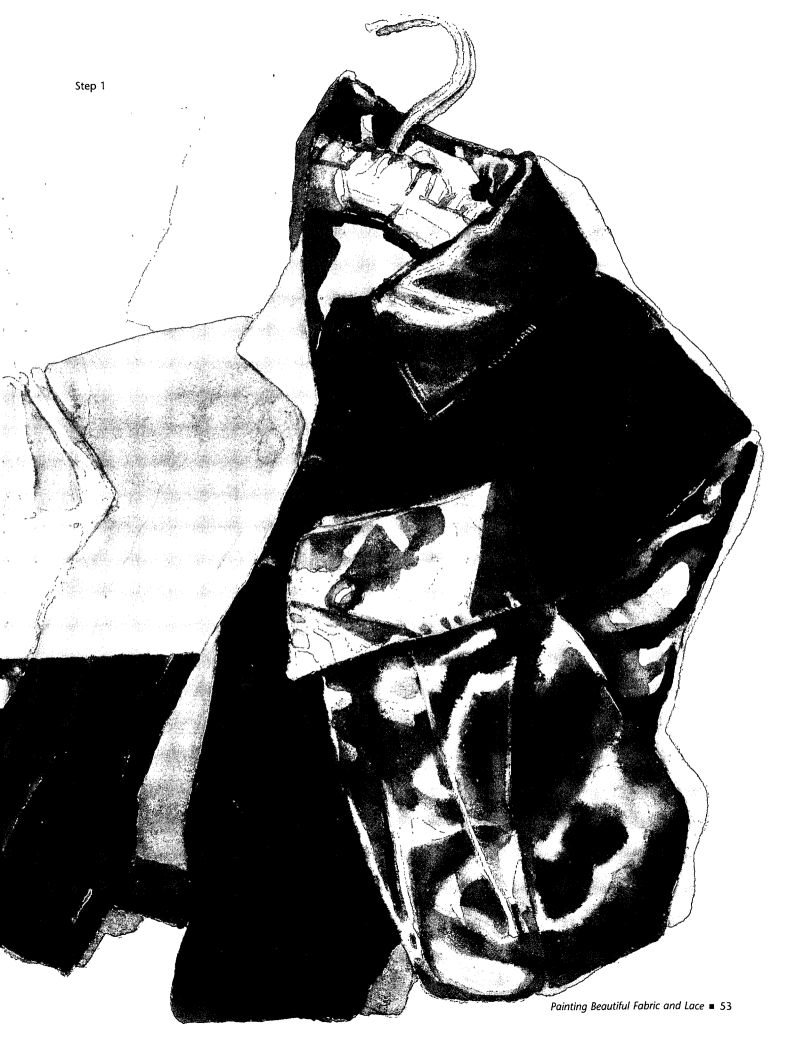

DEMONSTRATION

Print Fabric

Patterns on fabric follow and accentuate the curves of the folds and describe texture. Before you can draw their designs moving in and out of the folds, the underlying structure needs to be in place.

Color Palette
Cobalt Blue
Raw Sienna
Rose Madder Genuine
Viridian

1 Paint the Value Structure
Mix a good amount of wash for the lightest color and a darker wash for the shadows of the folds. The wash needs a spontaneous flow to it and you don't want to stop to mix more wash in the middle of your application. I used Raw Sienna and Rose Madder Genuine with Cobalt Blue added in the shadow areas for this underpainting. Notice how the shadow under the cloth causes it to pop out at you.

2 Draw the Design
The design is busy on this cotton print. I needed the fabric in my hands to draw the complicated flower pattern. Don't be concerned with every leaf and line, as you paint the impression and not every minute detail. The large shapes should be enough to help you find your way. After you draw the print on tracing paper transfer it to the underpainting already in place on your watercolor paper.

3 Paint the Pinks
Begin with the lighter colors of the design. Here I paint the light and dark pinks first using Rose Madder Genuine.

4 Paint the Greens
Add darker colors. The greens are Viridian with a touch of Rose Madder Genuine to gray them, and Raw Sienna to warm them. The pattern distorts as it moves around the folds.

5 Outline
The last touches are the fine outlines that appear around the design. This is where your no. 4 rigger brush comes in handy.

Wallpaper

C hoosing a wallpaper that picks up the colors of your still life will help unify your painting. Tack the paper behind your setup to see how it looks and check the color of any cast shadows. Wallpaper is printed like a silk screen, which means opaque colors are printed one at a time, going from light to dark, so this is how you will paint it.

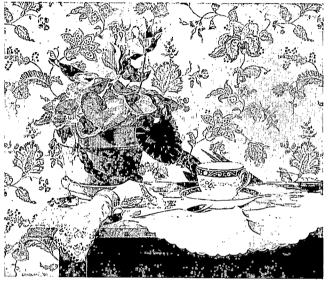

The wallpaper in this painting of cyclamen picks up the oranges and greens of the setup. These colors have been grayed in the wallpaper so it will stay in the background while the brighter color of the cyclamen keeps it in the foreground.

CYCLAMEN, 20½" × 24" (52cm × 61cm)
Collection of Mr. and Mrs. George H. Bohlinger III.

Color Palette
Cobalt Blue
Raw Sienna
Rose Madder Genuine
Ultramarine Blue
Viridian

1. Draw the Design
If you are working life-size (which I recommend to replicate textures and surfaces more easily), you can trace the design from the wallpaper itself and transfer it to your still-life drawing.

2. Wash in Background, Paint Reds and Oranges
Begin with a large wash of Raw Sienna and Rose Madder Genuine with a touch of Cobalt Blue to gray the mixture. You want to keep the wallpaper in the background so it shouldn't be too bright.

3. Paint Darker Colors and Soften
Paint the darker colors next using Viridian modified with Rose Madder Genuine and Ultramarine Blue with a touch of orange. Outline them with the green mixture. To soften the design and tone down the color I paint on a very thin wash of Cobalt Blue. Although the paint dried thoroughly before this last step, the greens still bleed a bit, but it adds to the soft effect.

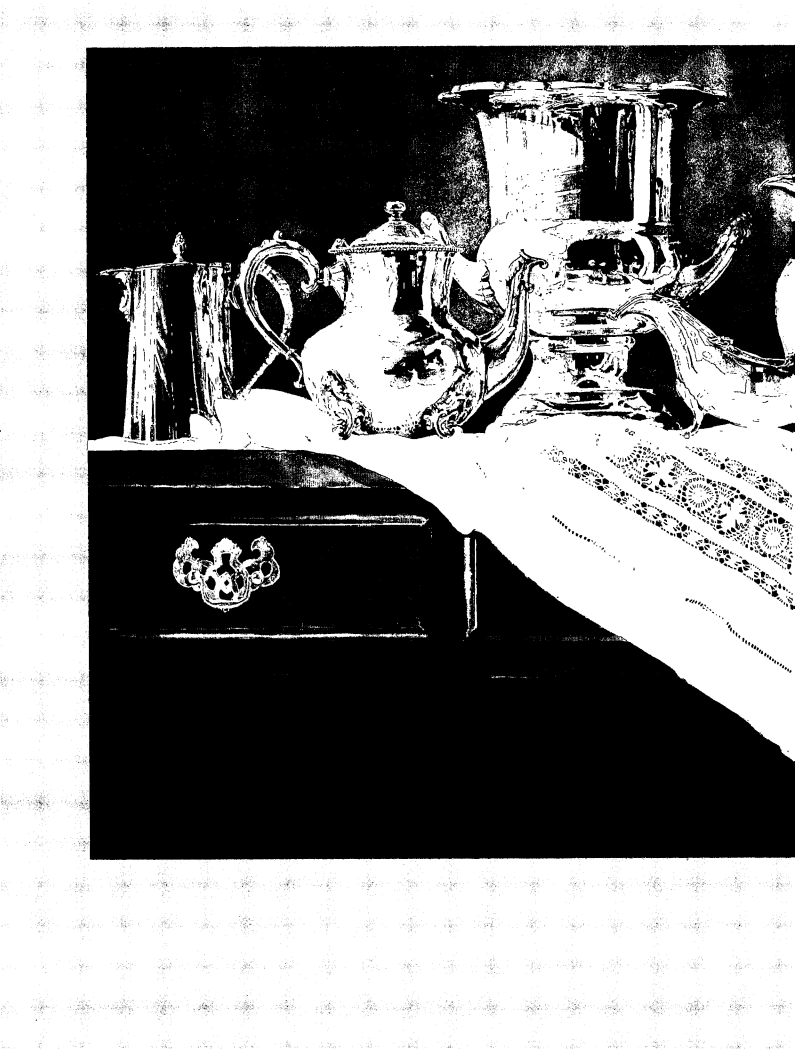

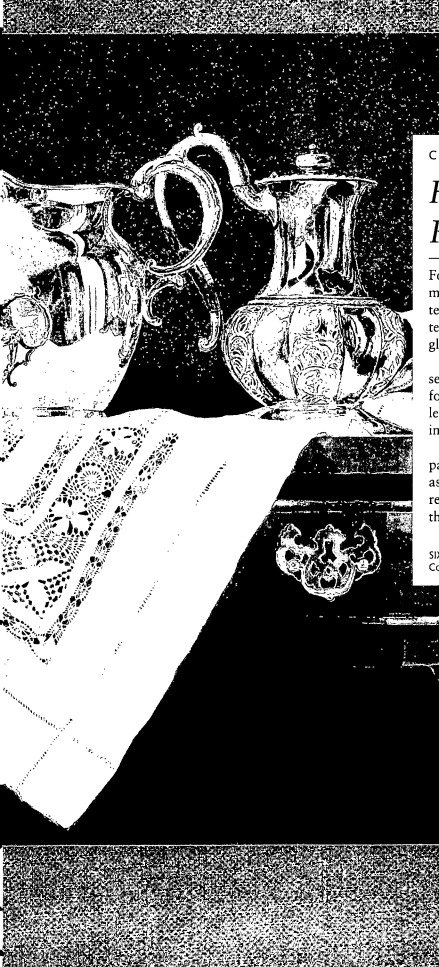

How to Paint Reflective Surfaces

For something to look real (as we see it), it must capture that fleeting impression of mystery the eye perceives as it moves about—an intensity here, a softness there, a diaphanous glimpse of reality.

The camera doesn't record things as the eye sees them. The camera lays everything out before you, near or far, in flat and focused detail, leaving little to hold your attention or prod the imagination.

When I use photographs as references to paint the reflections on shiny surfaces I am not as interested in getting exact copies as I am in revealing fractured abstract images that leave their identity to the beholder's interpretation.

SIX PIECES OF SILVER, 23"×35" (58cm×89cm)
Collection of Mr. and Mrs. Eugene Lopez.

Transparent Wine Glass

For the following demonstration of painting clear, transparent glass I use the same wine glass as used in the painting on this page, *Wine Pitcher*, but I give it a darker background. Glass shows up more dramatically when painted on a black background where you can easily distinguish background color from reflected color.

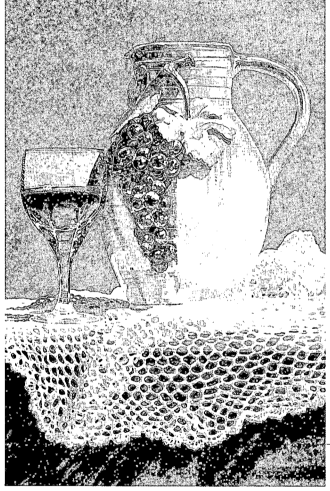

WINE PITCHER, 23″ × 15½″ (58cm × 39cm)
Collection of R. George and Associates.

Color Palette
Alizarin Crimson
Burnt Sienna
Cadmium Red
Cerulean Blue
Orange
Winsor Green

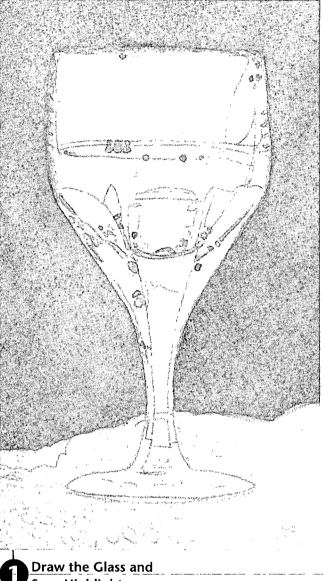

1 Draw the Glass and Save Highlights

Draw the glass on graph paper, plotting the curves so the glass is symmetrical. Transfer the drawing of your glass to watercolor paper and save the highlights with frisket. Tint the background with Burnt Sienna to warm the next wash.

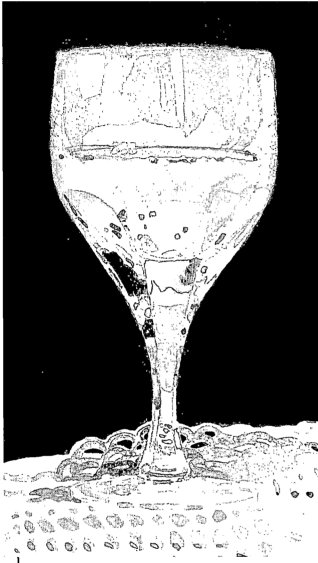

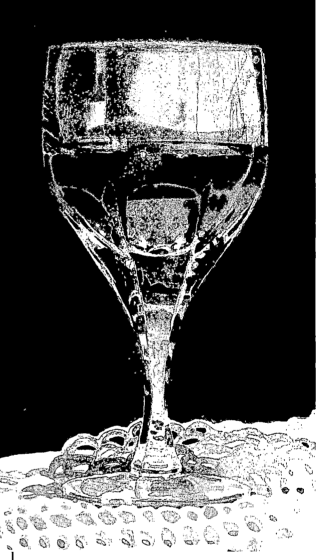

2 Apply Reflections and Background

The dark background is a mixture of Alizarin Crimson and Winsor Green. Some pale reddish washes of these colors begin to shape the bowl of the glass.

Put in the brightest reflected colors that sparkle all over the wine glass. I used spots of Cerulean Blue, Cadmium Red and orange to liven up the glass.

3 Paint the Darker Shapes and Blend

Apply the darks and neutral colors using Alizarin Crimson and Winsor Blue for the wine and the same colors as the background, Alizarin Crimson and Winsor Green, thinned with water for the grays. When all the shapes are painted, take a damp ¾-inch (19mm) flat brush and draw it down the bowl of the glass a few times. This blends the shapes so they don't look too choppy.

Green Glass Bottle

To capture the illusion of sunlight passing through colored glass use pure, transparent color. The reflections of green light spilling into the cast shadow of this reproduction of an E C Booz's Old Cabin Whiskey bottle are almost as intense as the green seen through the bottle.

Reference Photo

1 **Apply Initial Washes and Save Highlights**
Make a careful drawing of the bottle on graph paper, plotting the perpendicular sides, doors, windows and ellipse of the top. Transfer it to watercolor paper. Winsor Green and Aureolin Yellow best describe the "bottle green" color. Underpaint the shadow with this green color. Save the pure white reflections with frisket and paint the grayer highlights with a purple combination of Rose Madder Genuine, Cobalt Blue and Aureolin Yellow.

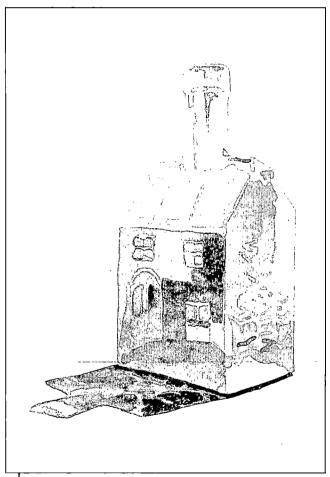

2 **Wash in Cast Shadow and Brilliant Greens**
Paint the cast shadow over the bright underpainting, allowing the brilliant green reflections to show through. Paint the most brilliant colors in the glass first.

❸ Add Darks, Adjust Values
Darker greens go on last. Achieve these darker colors by adding very little water and more red to your green mixture. With the darker values in place it's apparent the gray highlights must be a shade darker for the white highlights to register. Adjust values for maximum contrast then remove the frisket.

With the darker values in place it's apparent the gray highlights must be a shade darker for the white highlights to register.

After values are adjusted for maximum contrast the frisket is removed.

Lettering in Paintings
When describing lettering in your paintings, whether it's print on the page of a book, on a sign, or like here, on a bottle, lose or blur some of the letters. An otherwise fresh and spontaneous painting will be made tedious by laboriously detailed lettering jumping out at you. If some words must be legible put in just enough detail to make them decipherable and make them the focal point in your painting, while blurring other writing. You can appreciate this concept if you try to read surrounding words as you keep your eyes focused on one word in this line of type.

Delft Vase

Ceramic objects, even if their local color is white, need a grayed underpainting a few values darker than white so highlights will appear much lighter. This is what gives them a solid, hard and shiny quality.

Color Palette
Aureolin Yellow
Cobalt Blue
Rose Madder Genuine
Ultramarine Blue

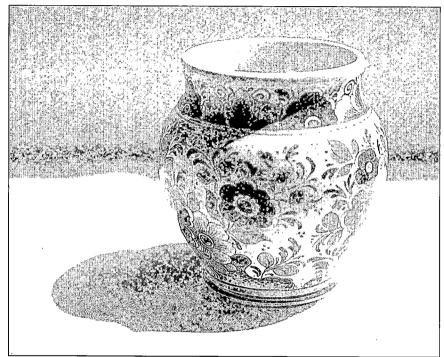

Reference Photo

1 Paint the Form
Draw this vase on graph paper, plotting the ellipses, and then transfer the drawing to watercolor paper. This opaque, ceramic delft vase has a pale blue cast. Before the design is applied the form must look three-dimensional. Paint the cast shadow using Rose Madder Genuine, Aureolin Yellow and Ultramarine Blue. While this is still wet, drop orange in to complement the blue of the vase and suggest reflected light. Save the highlights with frisket.

2 Paint the Shadow
Paint the shadowed side with Cobalt Blue modified with a little orange, leaving areas of reflected light.

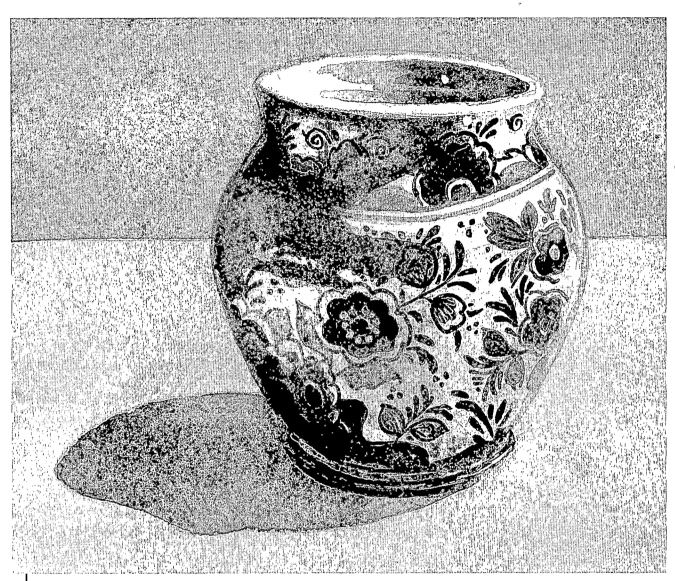

3 Paint the Design

When the shadow washes have thoroughly dried, transfer the delft design from your original drawing to the painting and paint the design. After this has dried, a Cobalt Blue wash painted over the left side mutes the design to give the sunlit design more impact and strengthen the contrast. Remove the frisket.

Shell on Mirror

Objects reflected in a mirror are reversed images and are not identical to the object being reflected. The mirror reflection of this shell appears as a slightly muted reflection of its other side. The highlight on the shiny inside of the shell becomes the lightest light so we'll save the white of the paper with frisket to show that. The darkest value (a reflection of the distant dark ceiling) sets off the light shell.

Color Palette
Aureolin Yellow
Cobalt Blue
Rose Madder Genuine

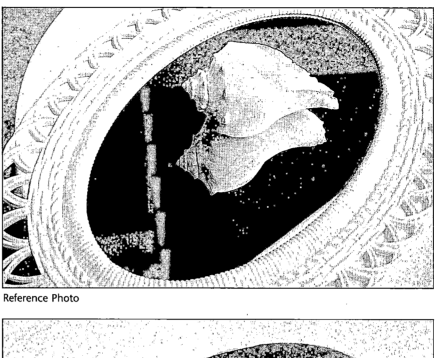

Reference Photo

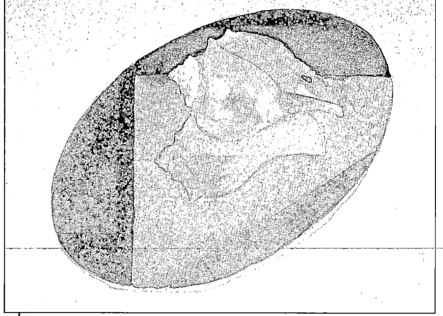

1 Paint Lighter Values, Save Highlights
If you are worried about losing the highlight, save it with frisket and you can be freer with your washes. Because the shell is the focal point, keep the reflections in the mirror as indistinct shapes. Place the darkest shape behind the shell to emphasize it. Begin laying in paler washes, using mixtures of Rose Madder Genuine, Cobalt Blue and Aureolin Yellow.

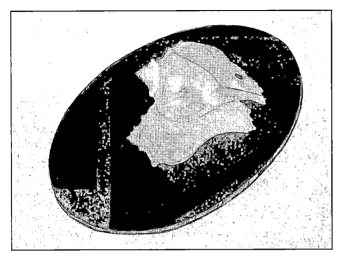

2 Add Darker Values

Paint darker reflected shapes in the mirror. Look for pleasing patterns or make them up. The delicate nature of Rose Madder Genuine, Aureolin Yellow and Cobalt Blue makes them the perfect triad of colors for painting shells. As you begin to build up layers of paint you can lift and blend these nonstaining colors.

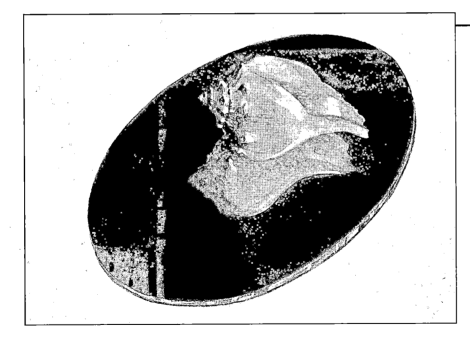

3 Add Reflected Light

Lastly, a 1-inch (25mm) flat, wet brush drawn across the mirror several times adds light reflections and mutes the reflection of the shell.

Still Life Through a Window

W hen a shadow of something, like this tree, falls on a window, you see more clearly what's inside. The inside is obscured where the sunlight filters through the leaves and reflects off the glass. The lightest value in this still life is the sunlight falling on the white mullion of the window. Use the white of the paper to show this and adjust every other value to this white.

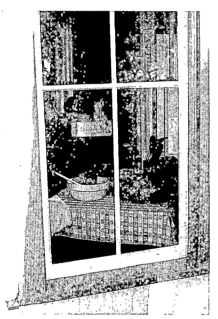

Reference Photo

```
Color Palette
Aureolin Yellow
Cobalt Blue
New Gamboge
Rose Madder Genuine
Viridian
```

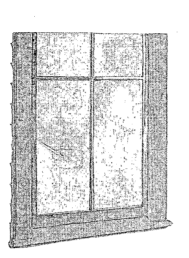

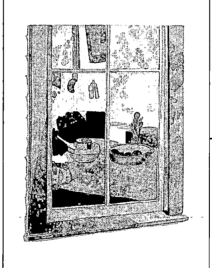

1 Apply Light Washes
As you draw the window make sure all vertical lines, such as the sides of the windows and mullions, are at right angles with the bottom of your paper. This is easy if you draw on grid paper and transfer your drawing to watercolor paper. Sunlight falling on the spoon handle, bowl and cloth are the lightest interior values so tint them with New Gamboge. Paint the windowpanes around these light objects a pale sky color, which will become the sky holes between the tree branches reflected in the window. The outside window molding is painted a sunny green color using New Gamboge and Viridian grayed with Rose Madder Genuine. Notice how the white window molding in shadow is a darker value than the green window molding in sunlight. Paint this darker value using a blue-gray mixture of Rose Madder Genuine, Cobalt Blue and Aureolin Yellow.

2 Save the Reflections, Adjust Shapes and Values
Save the window reflections with frisket applied over the dry blue wash, allowing freedom with the darker interior shapes and shadows. The frisket appears as gray-green spots in the upper windowpanes. As you paint the shapes visible through the window, check their value against the white window molding. Even in shadow the molding is lighter than everything in the window except the sunstruck spoon handle and cloth.

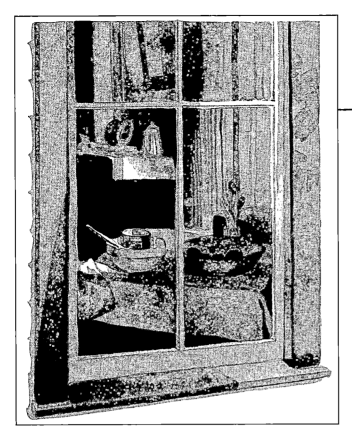

3 Darken and Blend

Cover all areas inside the window except the sunstruck objects with darker shades. Even with the frisket still in place we start to get the feeling of looking through glass into the room. Objects inside need to be darkened further and blended together more.

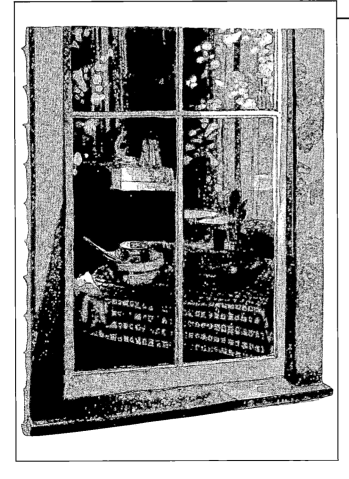

4 Values, Values, Values

This window is a great study in painting values. Compared to my initial value compass—the window molding—no matter how dark I think I've made some of the values, they are not dark enough. Finally, when they seem right, I remove the frisket and discover the original underlying reflection value is way too light. After adjusting that I darken the front plane of the windowsill to add weight to the bottom of the painting.

The Color of Gray

When you mix complements together to get gray, think of the grays as grayed color. Is it grayed purple or blue or green or red? Maybe it's a warm yellow gray. Push your grays toward one of the complements as you mix to keep them vibrant, alive and interesting.

Dogwood in Cut Glass

Reference Photo

The sparkling facets of cut glass define its visual identity. This cut-glass bowl of water and floating Chinese dogwood needs a dark background to set off these brilliant lights.

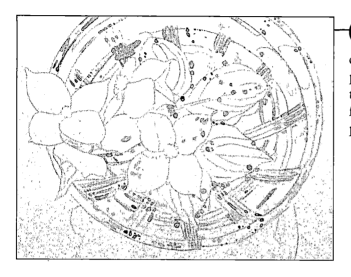

1 Draw, Transfer, Save Whites
Projecting your image is especially helpful when drawing complicated crystal patterns. Saving the sparkling whites gives you confidence to start the challenging painting.

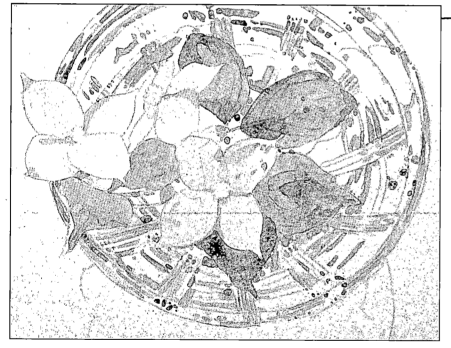

2 Add Color
Paint the small prismatic flecks of reds, yellows and blues that dance all over the sunlit glass. A pale—in some places blue—underpainting prepares the leaves for a brighter glaze. Paint the dogwood flowers with a pale wash of Aureolin Yellow with a little Rose Madder Genuine. The bright green underpainting for the leaves is a mixture of Winsor Green and Aureolin Yellow. Patches of Cobalt Blue describe the light-struck areas.

Color Palette
Aureolin Yellow
Burnt Sienna
Cobalt Blue
Rose Madder Genuine
Ultramarine Blue
Winsor Blue
Winsor Green

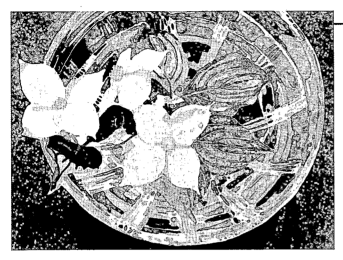

3. Paint the Background

Ultramarine Blue and Burnt Sienna make a nice grainy, neutral background color. Bring the background into the glass bowl, painting around the color shapes. We need lots of sharp edges to represent cut glass. Paint the cast shadow on the background color after it's dry, leaving patches on the bottom right where light comes through the glass.

Centers of the flowers are Aureolin Yellow with a touch of Winsor Blue. This color will be the light-struck areas. The darkest green determines the other values needed for the leaves, so paint in some of the darkest greens and then develop the other greens to sculpt the leaf shapes.

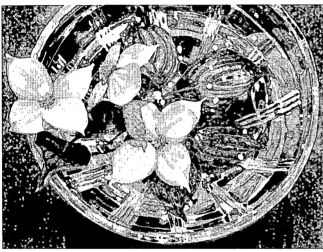

4. Develop the Flowers and Bowl

The flowers require delicate colors so paint the shadows using a mixture of Aureolin Yellow and Rose Madder Genuine with a touch of Cobalt Blue. Keeping the edges sharp, continue looking for shapes and patterns to paint in the crystal bowl until most of the bowl is covered with light and dark values.

The Incredible Nib, dipped in water, softens and rounds the outer edge of the bowl. Remove the frisket.

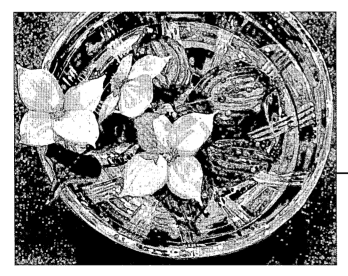

5. Paint Water Drops

Paint water drops on the leaves floating on the water. Use a wet brush on the water surface to soften and distinguish it from the bowl. After adding some darks and colors, the bowl of dogwood is complete.

Stems in Water

Distortions from refracted light occur in objects seen through glass. The water in this glass exaggerates this effect so stems and leaves at the water line appear disjointed.

Color Palette
Alizarin Crimson
Aureolin Yellow
Cobalt Blue
Rose Madder Genuine
Ruby Red (LeFranc & Bourgeois Linel)
Viridian
Winsor Green

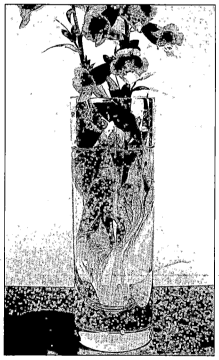

Reference Photo

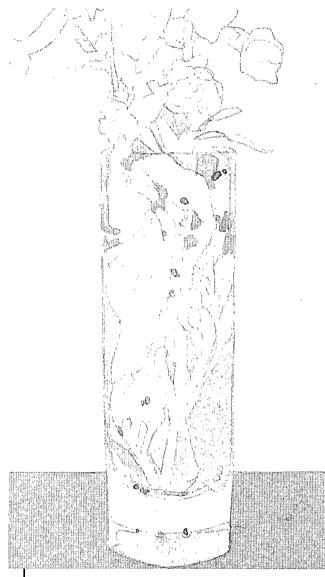

1 Paint Background Color, Save Highlights
I pick a modified yellow color for the background to complement the purple foxglove. Save a few highlights so they won't be lost when the dark leaf values are applied. Bring the same background wash into the vase and paint another coat of background color over the tabletop.

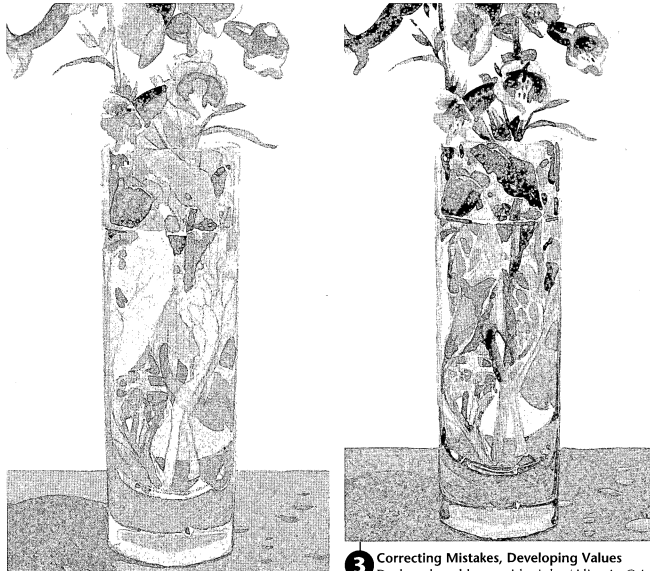

2. Paint the Cast Shadow and First Washes

Paint the cast shadow and water spills using a purple version of Rose Madder Genuine, Cobalt Blue and Aureolin Yellow. Some of the purple color is brought into the vase. Leaves and flowers are underpainted with pale greens and roses. I choose Ruby Red, a LeFranc & Bourgeois Linel watercolor, for the foxglove. Mix this with a little Viridian for the shadow areas of the flowers. Because of the purity of flower colors it's difficult to get just the right color by mixing, so I keep a collection of small tubes of reds and purples for flowers.

3. Correcting Mistakes, Developing Values

Darken the tabletop with violet (Alizarin Crimson and Cobalt Blue). The yellow underpainting shows and grays or modifies the violet. The reflection in the bottom of the vase must be a version of this color so add a yellow glaze. Accidental discoveries keep the painting process exciting. For example, I should have treated the tabletop and reflection in the bottom of the vase alike. I like the bit of purple showing through the bottom of the glass so it wasn't wrong.

Obtain bright saturated leaf colors by mixing Winsor Green and Aureolin Yellow. Be careful, these colors can overpower a painting. For subtle shades of green try Viridian and Aureolin Yellow with Rose Madder Genuine to modify or Alizarin Crimson to darken. Paint the green segments between the leaves first, leaving the yellow background as veins. When dry, blend with a damp brush. Remember the cylindrical shape of stems as they turn from light to shadow to reflected light. Use a large round brush (no. 10). Change color and value on the paper as you paint rather than mixing separately on your palette.

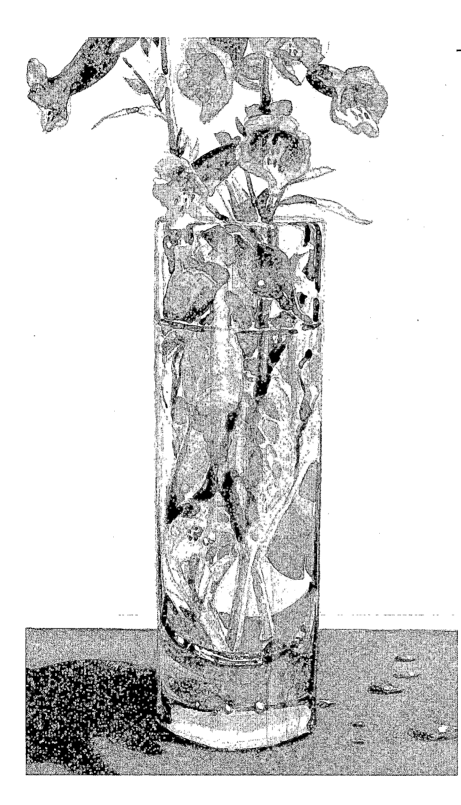

4. Add Darks for Contrast and Remove Frisket

The spaces between stems and leaves where the background shows through look too light. This is an optical illusion that happens when dark areas surround a light area. (In landscape painting these would be called sky holes and are always painted darker than the sky to compensate.) Make these areas a shade darker using another coat of the background color. Remove the frisket and bring some darker values into the leaves in water and the glass vase. A wet brush, drawn down the side of the glass, adds a highlight. Darken the cast shadow and scrape highlights in the water drops on the tabletop.

Blotting
Keep a tissue on hand to quickly blot any passages that appear too dark. But use it only when absolutely necessary. Lots of fresh color is lost by the tentative blotting of an unsure hand. Usually it's better to let the value dry and then see how you like it. You can always wet it again and then blot or lift with a brush if it's not right.

Verdigris Frogs

These whimsical verdigris bronze frogs are a nonreflective metal that lends itself to an opaque portrayal. There are no white highlights so frisket is not used in this painting.

Reference Photo

Dry Brush
Dry brush is the technique of using a brush with mostly pigment and very little water. After loading your brush with the desired color, stroke it across a swatch of rough watercolor paper or a sponge until it has lost most of its moisture and leaves a dryish, ragged swatch of paint.

1 Paint Light Values and Cast Shadow

After the frogs are drawn and transferred to watercolor paper start with the palest chalky green color, Cerulean Blue with a little Aureolin Yellow and Rose Madder Genuine to modify it slightly. Use an orange mixture of the same colors for the shadow to complement the blue.

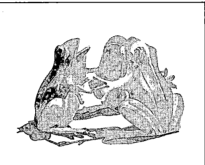

2 Mid-Values

While the first washes are slightly wet, paint a darker mixture of the same colors for the mid-values.

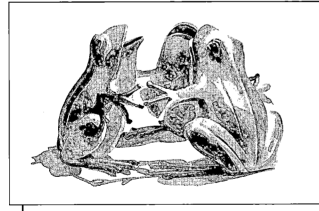

3 Darkest Values

Use Cerulean Blue modified with Rose Madder Genuine and Raw Sienna for the dark shadows. Shadows are warm in holes, such as the frogs' mouths. Drop Rose Madder Genuine into this dark value to heat it up.

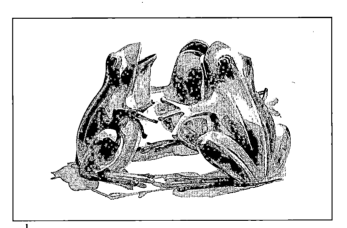

4 Add Color and Texture Interest

The frogs look a little too monochromatic so add some orange washes on the two frogs in front. This adds color interest and separates them from the back frog. Dry-brushed texture using the shadow color better describes the pounded metal.

Silver Gravy Boat

'␣ve used this silver gravy boat in many paintings because it's fun to paint. It has a graceful, feral quality and looks to me as though it is at attention, tail up, ready to spring.

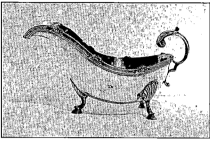

Reference Photo

Color Palette

Burnt Sienna
Cobalt Blue
Raw Sienna
Ultramarine Blue

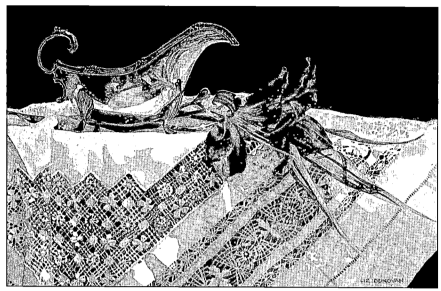

GRAVY BOAT WITH DAYLILY, 10½"×16" (27cm×41cm)
Collection of Pat Daniels.

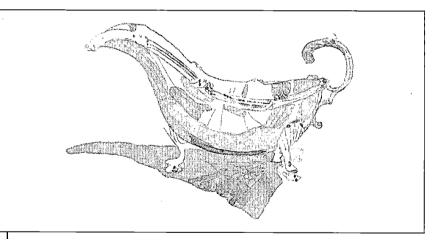

① Draw, Transfer, Save Highlights

Make a careful drawing on graph paper and transfer it to watercolor paper. Save highlights with frisket and begin with pale washes. Cobalt Blue and Burnt Sienna make a good tarnish color. You don't really need to save whites with frisket in this exercise. You can paint around them, and if you do lose some they can be recovered with liquid correction fluid or by scratching with a craft knife. It can be comforting to know they are saved, though, so you can approach the washes energetically.

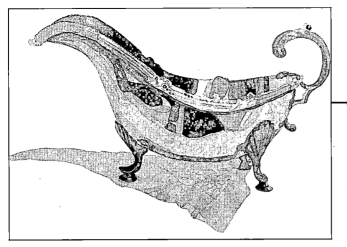

2 Look for Colors, Shapes and Values

Silver has very little color. It reflects all the surrounding colors and values, so have fun looking for as many colors as you can find and some you make up. Paint these colors and shapes quickly, while the paint is wet enough to diffuse into the next color.

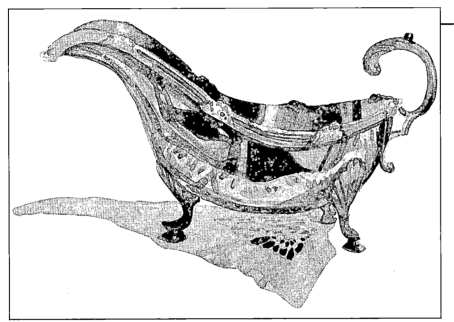

3 Paint the Darkest Accents

An almost black mixture of Raw Sienna and Ultramarine Blue will make the gravy boat appear to shine even before you remove the frisket. Accent rather than outline as you apply the darks. Leaving the lighter wash colors on the outside edges will give your objects more form.

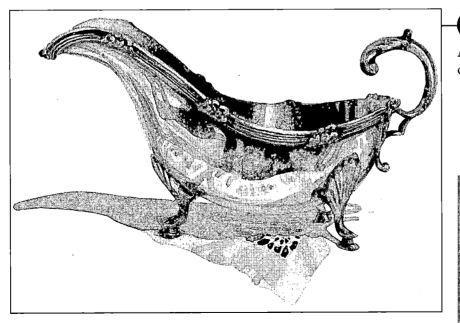

4 Remove Frisket and Finish Details

Add a cast shadow, sharpen some details and darken values.

Recovering Highlights

To recover lost white highlights let the paint dry completely and use a craft knife to pick or scrape back to the white paper. This is best done as a last step as once the paper is disturbed it won't accept paint as well.

Copper Oil Lamp

T his copper oil lamp is a good study in painting both glass and metal. Glass and metal are both hard, shiny surfaces, but glass allows the light to pass through while metal reflects back any of the colors and objects surrounding it.

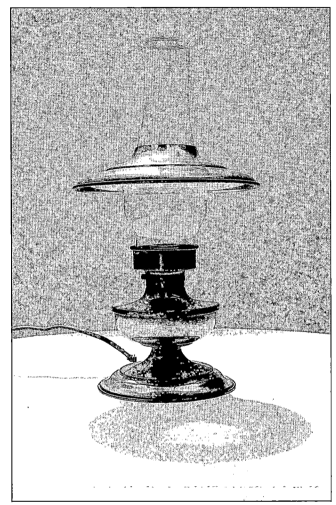

Reference Photo

Color Palette
Alizarin Crimson
Aureolin Yellow
Cadmium Red
Cobalt Blue
New Gamboge
Rose Madder Genuine

1 Draw the Lamp, Paint the Background
As you draw the lamp you'll encounter many ellipses. See page 25 for tips on the circle drawn in perspective. If you're having trouble getting the lamp symmetrical, draw one-half of the lamp, fold it in half and trace the other half. Paint a background color to help the rendering of the glass. I chose blue to complement the orange copper color and tinted the table yellow. Save two highlights on the lip of the glass cone. The background color is brought into the glass cylinder. Distortion is caused by light waves bending in the glass. Reflections of light bounce off the glass causing areas of lighter value.

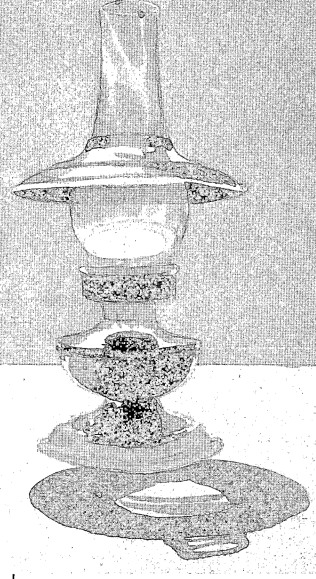

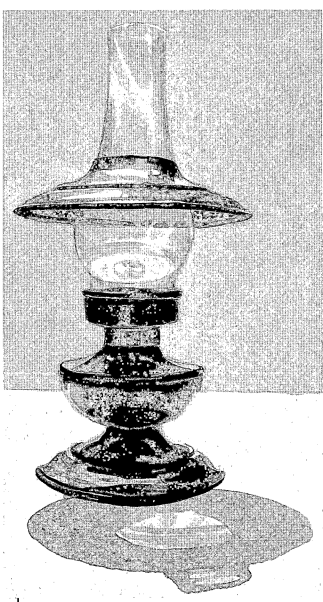

2 **Paint the Cast Shadow,
the Lighter Copper Values**
A blue cast shadow will complement the orange of the copper metal. Copper reflects light as a bright orange color. New Gamboge and Cadmium Red make a good orange for the brightest areas. Diluted Rose Madder Genuine and Aureolin Yellow are mixed with a bit of Cobalt Blue for the delicate orange passages.

3 **Add Darks**
Alizarin Crimson, New Gamboge and Cobalt Blue with very little water added are used for the darkest value. The oil lamp is backlit by the sun but there is a lot of reflected light bouncing around in the copper. These darks give it some solidity. Remove the frisket.

DEMONSTRATION
Brass Teapot

Reference Photo

While brass is as reflective as silver it has its own color identity, and lights reflected off its surface will be orange or yellow. Shadows take on a green cast. Even the lightest highlights will have a tint of yellow in them. In the transition area from lightest highlight to shadow is where you will find the most color saturation of pure yellow.

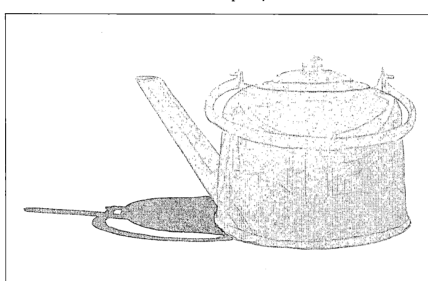

1 Draw, Paint Cast Shadow and First Wash

Draw the teapot on graph paper and correct the perspective. Paint the whole teapot with what will be the lightest value, New Gamboge, keeping the top lighter because it's closer to the sun. The cast shadow is purple (Cobalt Blue, Rose Madder Genuine, with a touch of yellow to gray it down) to complement the yellow brass. While the cast shadow wash is still very wet drop a bit of New Gamboge in for the reflected light from the brass pot.

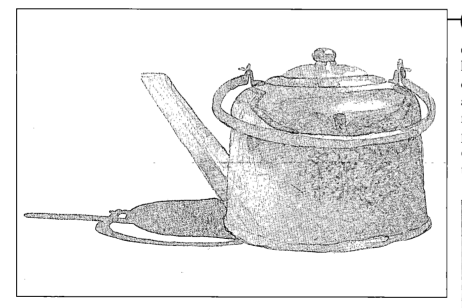

2 Look for Reflected Color

Now that the lightest color is established everything but the highlights can be covered with darker colors. I see oranges, greens and yellows. Since we are not using frisket in this exercise, be careful to preserve the light areas. A barely damp brush diffuses the edges of the highlights.

Color Palette
Alizarin Crimson
Cobalt Blue
New Gamboge
Raw Sienna
Rose Madder Genuine
Winsor Green

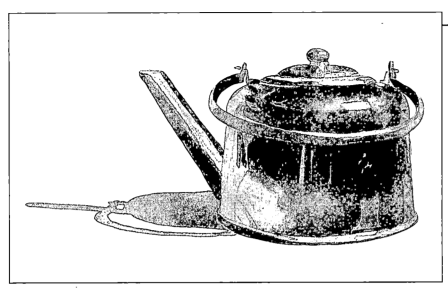

③ Keep Edges Soft
Darken values as you keep everything slightly damp. If things dry too much, edges can be softened with a damp brush and areas can be reworked. Keep the edges soft because the patina of the polished metal has no sharp reflections except on the handle. A sharper edge will help the handle advance. Light areas can be recaptured by blotting wet paint with a tissue.

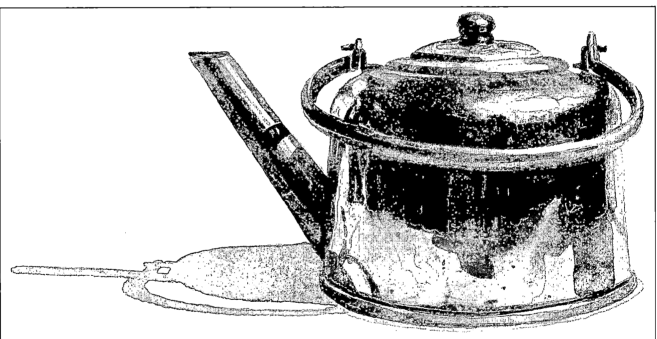

④ Strengthen Values, Paint Cast Shadows
For the darker cast shadows on the teapot from the handle I use a mixture of Cobalt Blue and Raw Sienna with a touch of Rose Madder Genuine. Darker shapes are painted and the handle's cast shadow goes on the pot and its spout. The darkest color—a mixture of Alizarin Crimson and Winsor Green with a touch of yellow—is saved for a few small accent areas on the spout, around the rim of the base and where the handle is attached. Finally a few dots suggest the small corrosion pits.

Brass Drawer Pull on Wood

D rawing these handles so they are symmetrical is sometimes a frustrating experience. Blue grid paper will help with measuring or you can draw one side on tracing paper, fold it in half and draw the other side.

Color Palette

Alizarin Crimson	Cobalt Blue
Aureolin Yellow	Raw Sienna
Burnt Sienna	Rose Madder Genuine
Cadmium Red	Ultramarine Blue
Cerulean Blue	

Reference Photo

1 Begin Handle and Washes
Draw the handles and paint the first washes. The photograph has too much light exposure. Keep the grayed look of the light-struck wood but tone it down. Apply a wash of Cobalt Blue modified with just a touch of Rose Madder Genuine and Aureolin Yellow first. Paint the handle the lightest yellow using diluted Aureolin Yellow. At the bottom try out a mixture of Raw Sienna and Alizarin Crimson modified with a little Cobalt Blue for the basic wood color.

2 Paint Underlying Wood Color
Bring the Raw Sienna, Alizarin Crimson and Cobalt Blue mixture across the drawer front, varying the mix and leaving some of the blue underwash showing. Some orange begins to describe the handle.

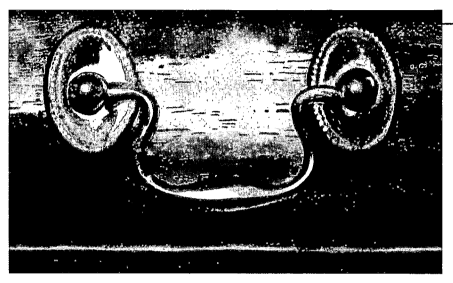

3 Add Wood Grain and Darks
Paint little bits of grain in the wood using Alizarin Crimson for the light-struck areas with Ultramarine Blue added for the darker areas. The dark parts of the brass handle are Raw Sienna and Cobalt Blue. The reflected light is orange. Touches of Cerulean Blue cool the brass in spots and parts of the brass are darkened. Don't outline every little bead on the drawer pulls, just suggest them. I highlight the little grain slits with frisket slashes over the drawer surface as an experiment, not knowing how it will turn out.

4 Finish
Streaks of blue (Cobalt Blue), purple (Alizarin Crimson and Cobalt Blue) and Cadmium Red finish the wood grain. Removing the frisket after this wash dries reveals highlighted pits of the wood grain. Some of the brass handle's highlights are recovered by lifting the shadow color with a damp brush and tissue. Finally, add the handle's cast shadow using a mix of Burnt Sienna and Ultramarine Blue.

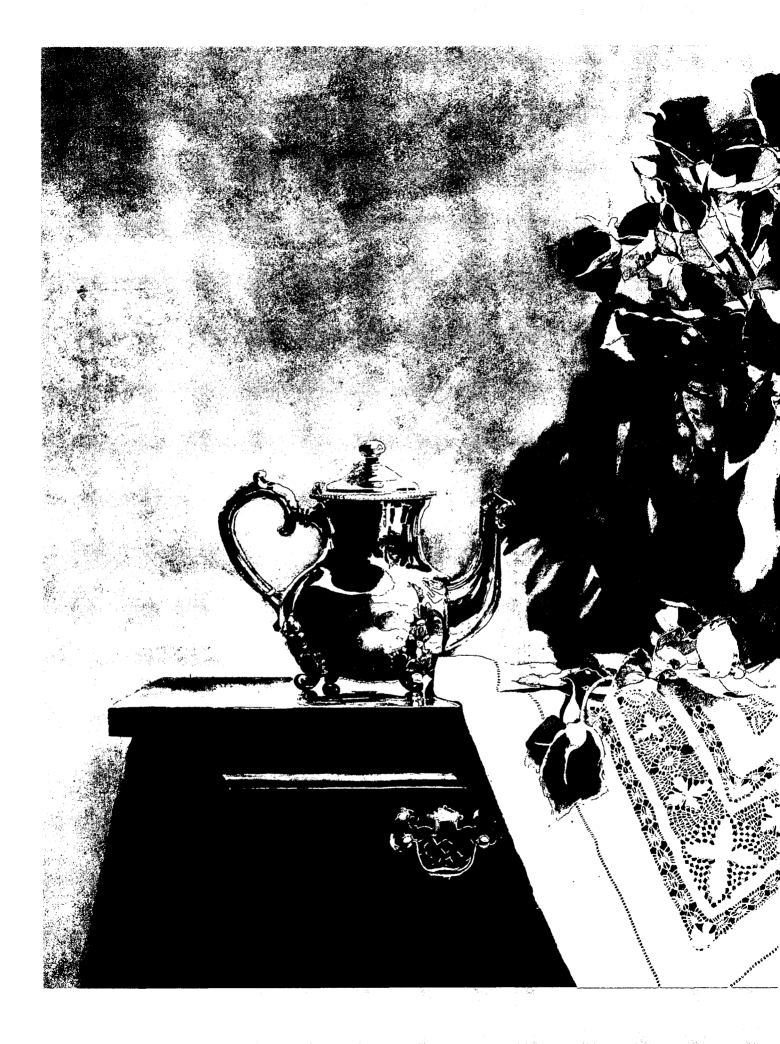

CHAPTER FIVE

Painting Rich Wood and Marble Surfaces

Rendering wood and marble is easiest using glazing techniques. For wood, analyze the underlying color and then consider the way trees grow and the angle of the cut. As trees grow they form annual rings. Each ring includes a wide, light ring from spring growth and a dark, narrow ring of summer growth. The way the grain of these rings is revealed depends on the way the tree is cut. This explains the characteristics of the grain you are trying to replicate.

Notice the translucency of marble and its various masses, drifts and veins of color that define its character. If you master the methods of painting one kind of wood or marble you will be able to transfer those skills to other varieties by closely observing the changes in color and the direction of its veins or lines.

RED ROSES, CUT GLASS VASE, 36″×46″ (91cm×117cm)
Collection of Kenneth R. Woodcock.

Oak

Large fibrous pores along the grain lines of oak make it easily identifiable. These dark fibers make the grain lines more noticeable against an orange background.

Color Palette
Alizarin Crimson
Raw Sienna
Ultramarine Blue

Heartgrain
When parallel boards are cut lengthwise from the tree, v-shaped lines called heartgrain are exposed.

1 Paint Underlying Color
Paint bright orange as the color that will shine through your subsequent washes. Let this color dry thoroughly and draw the heartgrain pattern.

2 Apply Grain Strokes
The dark color I use over the bright orange is a mixture of Alizarin Crimson and Ultramarine Blue with a bit of Raw Sienna. Brush on strokes of this color following the grain lines you have drawn. These strokes should be thicker at the point of the heartgrain line and thinner for the sides.

3 Apply Vertical Lines
When these brushstrokes have dried use the chiseled end of a ½-inch (12mm) flat brush dipped in the same color to apply little vertical lines along the grain lines. Then use the same method with shorter and paler lines in rows across the entire surface to represent pores.

Rosewood

This is a stylized rendering of rosewood. Red shows through, and even though we use the same dark color as we used over the orange of the oak wood, the appearance is quite different here.

Color Palette
Alizarin Crimson
Raw Sienna
Ultramarine Blue

Straight Grain
Straight lines of grain appear when the tree is cut lengthwise in quarters, and these wedges are then cut into boards.

1 Paint Bright Red
The bright underpainting is Alizarin Crimson. Paint wavy stripes getting wider toward the foreground with a mixture of Alizarin Crimson and Ultramarine Blue and a touch of Raw Sienna.

2 Paint the Fibrous Pores
Using the edge of a ½-inch (12mm) flat brush dipped in this same color make small slits in a somewhat circular pattern to simulate pores.

Painting Marble

Color Palette
Cobalt Blue
Raw Sienna

Rendering marble lends itself to glazing techniques to capture the translucency of the stone. The veins that seem so random should really be carefully designed shapes. One way is to draw them as somewhat elliptical shapes laid next to each other with common sides. Vary the sizes of the shapes and the width of the lines that describe them. With a well-designed drawing you will be ready to experiment with layers of paint.

Capturing Translucency

Once you have organized the veins into pleasing shapes you are ready to layer transparent colors onto your drawing. Marble comes in many shades but for this exercise we are using Raw Sienna and Cobalt Blue. You will work wet-in-wet so have tissues ready for the blotting stage.

1 Layer Color
First apply a wash of Raw Sienna. While this is wet, apply another wash of Cobalt Blue over that.

2 Blot in Texture
Before these layers have a chance to dry, crumple a tissue and blot the color, leaving light spots.

3 Paint Veins
Paint the vein pattern, varying the width of the lines. Lift a highlight along the edge with a damp brush.

Black Marble

Black marble with white veins presents a challenge to the watercolorist. Painting around the veins would make them too stiff and regular. You could use opaque white but this would turn your transparent colors chalky.

1 Brush Frisket Into Wet Paint
Apply a light color wash, blending Cobalt Blue, Rose Madder Genuine and Raw Sienna on the paper so you can still see their distinct color changes. To capture the flowing molten rock character of the veins, paint liquid frisket along the veins while they're still wet so the frisket disperses into the background somewhat.

2 Paint Dark Shapes
Place puddles of Alizarin Crimson, Winsor Green and Cobalt Blue on your palette and mix them only slightly. Paint the dark mixture over your vein design, again, varying the color. This is a time when blooms and other imperfections will work to your advantage.

3 Remove Frisket and Blend
Remove frisket and, with a damp 1-inch (25mm) flat brush blend veins further.

Wood and Marble: A Marble-Top Dresser

I use this antique dresser in many of my still lifes. I like the warm translucent marble top and the glowing red cherry wood. I have tilted this drawing more than I normally would to give the marble top equal importance.

Color Palette
Alizarin Crimson
Aureolin Yellow
Burnt Sienna
Cobalt Blue
New Gamboge
Raw Sienna
Rose Madder Genuine
Ultramarine Blue

Reference Photo

Frisket Applied

Drawing is tilted giving equal importance to the top for instruction.

1 Save Drawer Pulls, Table Edge and Paint Veins

Make a careful drawing of the dresser and the marble top. Draw then paint the marble veins, making sure to vary their shapes and the width of their lines. Save the drawer pulls and table edge with frisket. Using Cobalt Blue with a little Rose Madder Genuine added, paint the bluish highlights between the drawers and on the carved post.

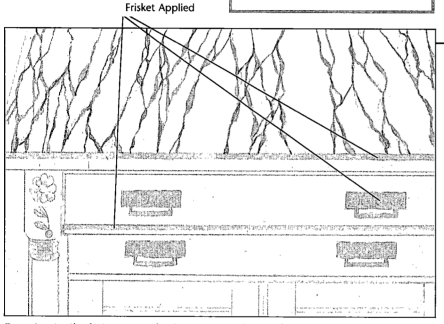

2 Texture Marble, Underpaint Wood

Paint a mixture of Rose Madder Genuine, Aureolin Yellow and a touch of Cobalt Blue (darker toward the front, lighter toward the back) over the marble top. Before this dries, take a crumpled tissue and blot out some of the color. This adds a light texture to the marble. The pencil marks showing through this transparent layer work well. The undercoat of the bright cherry wood is New Gamboge with Rose Madder Genuine. As you paint this wash there is no need to be too careful as long as you follow the grain with your brushstrokes.

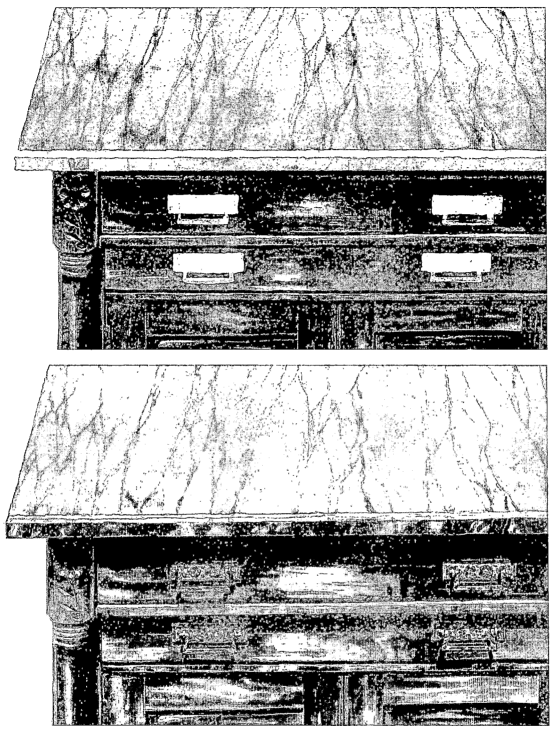

3 Paint Red Washes, Suggest Grain

Apply washes of Alizarin Crimson with a little Ultramarine Blue, Rose Madder Genuine and New Gamboge over the bright yellow-orange color to suggest grain, letting the undercoat show through in places. For the dark crevices around the drawers and in the design on the post use a mixture of Ultramarine Blue and Burnt Sienna. Remove the frisket.

4 Paint Handles and Cast Shadows

Paint the edge of the marble top darker than the surface, leaving a thin strip of highlight. Redraw the handles where frisket has pulled off the graphite lines of the initial drawing. Paint these handles using a Cobalt Blue wash for the dusty crevices and Raw Sienna darkened with Burnt Sienna for the design. Don't get too fussy with details, just suggest the design and let shadows do the rest. The cast shadow for the handles, marble top and the upper drawer hanging out over the bottom drawer are painted with a transparent shadow color (Alizarin Crimson, Ultramarine Blue and a bit of Aureolin Yellow to modify).

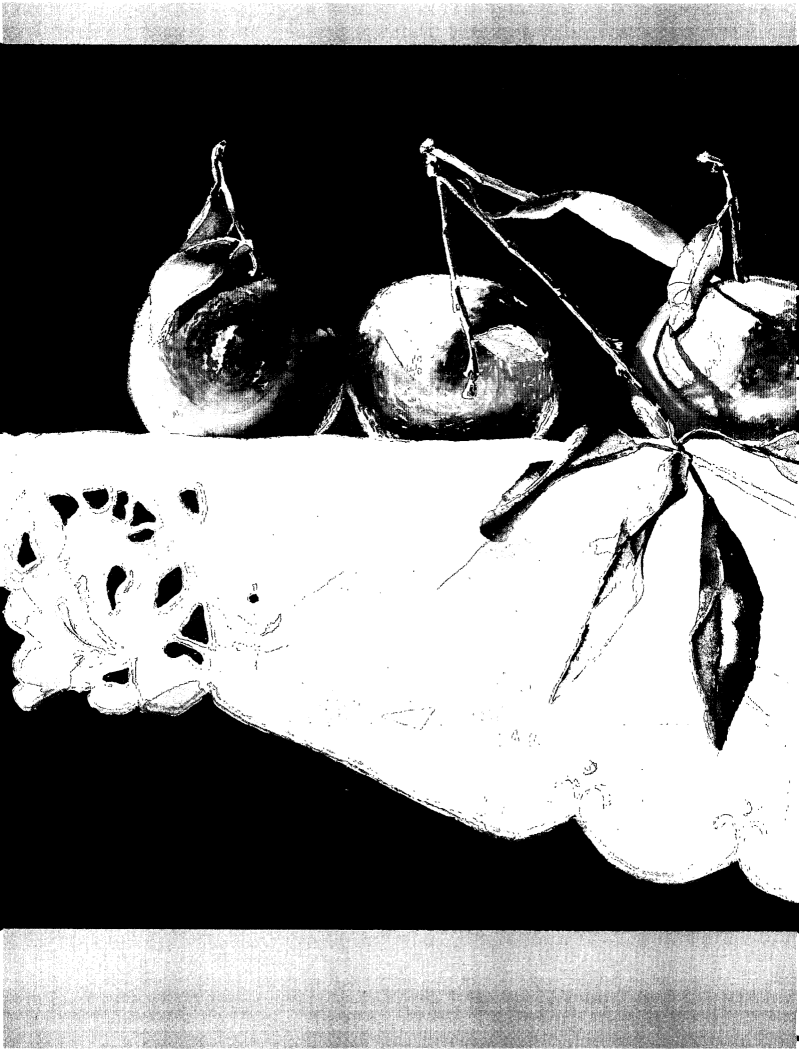

Painting Lush Flowers and Fruit

A visit to your supermarket is an inspirational experience when looking for subject matter. Fruit and vegetables come in a limitless selection of textures and colors. Choose so their colors will harmonize and or complement each other in color and vary their textures and sizes. Cutting open a piece of the fruit in your painting adds interest as does partially peeling the fruit and then letting the peel spiral down over the edge of the tabletop. Look for fruit with leaves or stalks attached and let them hang over the table's edge to break up that long line parallel to the bottom of your paper. You can also zero in on an active part of the plant to give a realistic painting an abstract quality.

Flowers in sunlight are a good study of the value of pure color. Because you are trying to capture the purest of color intensity, very little color mixing is done. You must count on water to lighten the values and the white of the paper to reflect light through pigment to capture the brilliance of the color. This is an impossible task as white paper and paint is no match for the brilliant hues of nature.

FIVE TANGERINES, 16" × 25" (41cm × 64cm)
Collection of Karen Donovan.

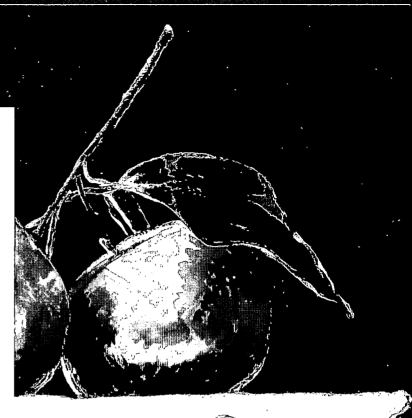

Painting Leaves

B efore tackling a painting of fruit and flowers you must know about their leaves. You'll find their leaves more varied in texture and shape than the fruits and flowers themselves. Some leaves are soft and fuzzy, some have a waxy shine, and some are covered with tiny veins. Whatever their character they sometimes identify a plant more exactly than the characteristics of its flower or fruit, so a realistic painting requires close observation.

As you paint leaves and stems you will need a good green vocabulary. This list of greens contains a broad range, from bright-intense to delicate, from yellow-green to blue-green.

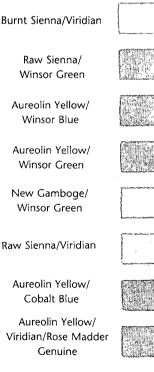

Burnt Sienna/Viridian

Raw Sienna/
Winsor Green

Aureolin Yellow/
Winsor Blue

Aureolin Yellow/
Winsor Green

New Gamboge/
Winsor Green

Raw Sienna/Viridian

Aureolin Yellow/
Cobalt Blue

Aureolin Yellow/
Viridian/Rose Madder
Genuine

Aureolin Yellow/Viridian

Fuzzy Leaf—African Violet

I use Alizarin Crimson with a touch of Viridian to paint the red underside of this African Violet leaf. While this wash is still wet wipe the brush dry and lift out the veins. As you paint these fuzzy leaves it works better to keep everything damp and make your color and value transitions on the paper. I use Viridian and Burnt Sienna for the dark green and change to Raw Sienna in the light-struck areas. The hairs all over the stem and top of the leaf give it a gray halo effect.

Waxy Leaf—Jade Plant

The jade plant has a waxy, thick leaf that allows little light to pass through. It's better to paint all at once, wet-in-wet, to capture the curve of the leaves. After dulling them a bit with a blue wash I save the crucial highlights that will describe the shiny surface with frisket. As in most curved surfaces we move from one side of a leaf to the other starting with a warm color on the energy side, moving into a dark shadow and finally a cooler reflected light on the other side.

Concave and Convex

In drawing things of nature, concave lines are weak and do not strengthen your design. Convex lines, however, portray the bursting forth of growth and are considered strong marks or shapes. Whenever possible use convex lines and shapes to describe what you are painting. This applies to the inorganic matter of your still lifes as well. Man-made objects, even the folds of cloths, should have strong convex shapes rather than weak concave ones.

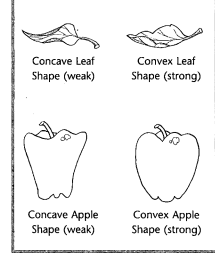

Concave Leaf Shape (weak) Convex Leaf Shape (strong)

Concave Apple Shape (weak) Convex Apple Shape (strong)

Shiny Leaf—Philodendron

Philodendron has an expressive, transparent, bright green leaf. I use it a lot as background in my still lifes as it reflects sunlight in pleasing patterns. When sunlight passes through or bounces off the leaves, warm yellow-greens are revealed while the shadows are a cool blue. Aureolin Yellow and Winsor Green are good for bright greens and yellow-greens, while Winsor Green and Cobalt Blue make nice blue-greens. Layer the greens to darken areas and paint in the darker veins.

Complicated Leaf—Fern

Ferns are nature's version of lace and we will paint them in a similar way. Think of them as a solid leaf with holes. Don't paint each tiny little leaf on the stems of the fern. Instead, make a careful drawing and save the holes with frisket. Paint in some yellow lines for stems, then paint the whole shape, varying the color from orangey greens to yellowish greens to blue-greens. Remove the frisket, reshape a few holes, reclaim a few stems and it's finished.

Cantaloupe With Apples

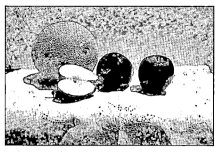

Reference Photo

The cantaloupe in this demonstration contrasts nicely with the apples. Its rough, detailed greenish hide accents the shiny, deeply saturated red of the apples' skin. To set the stage for the highlights on the apples (the lightest value in the painting), we will tone the background a grayed yellow and give the tablecloth a very light Cobalt Blue wash.

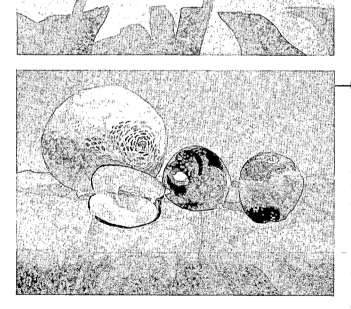

1 Paint Light Values, Save Highlights

After transferring the drawing to watercolor paper, paint the background a value slightly darker than the lightest part of the cantaloupe. Paint the cantaloupe Aureolin Yellow, Rose Madder Genuine and a touch of Cobalt Blue to modify. This value should be the lightest part of the raised texture of the melon. A bluish wash on the tablecloth gets a few dark shadows in the folds (Cobalt Blue with Rose Madder Genuine and Aureolin Yellow to modify). Notice we have used the same three colors to mix many different colors.

2 Develop Apples, Soften Cloth

Soften the folds of the cloth with more violet-tinted shadows to complement the yellowish background. Paint the stem of the melon yellow-green and begin to describe the dimpled skin. Notice how the pattern swirls around the stem and gets larger as it moves out to the body of the melon. To make the melon look rounded, the pattern gets closer together and more indistinct as it recedes. A shadow is added (Aureolin Yellow and Winsor Violet) that gets lighter at the bottom from reflected tablecloth light. Save the highlights with frisket and begin the apples with cool and warm washes of red using diluted Alizarin Crimson for the purplish reflected light, New Gamboge dropped in around the stems and Cadmium Red for the bright red nearer the highlight. Paint the inside of the cut apple with a thin wash of New Gamboge and a touch of violet, leaving a few white paper sparkles to make it look wet.

Color Palette

Alizarin Crimson	New Gamboge
Aureolin Yellow	Rose Madder Genuine
Cadmium Red	Viridian
Cobalt Blue	Winsor Violet

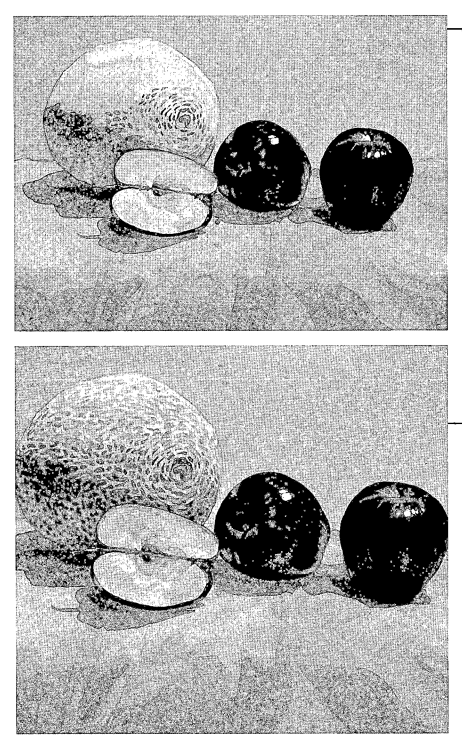

3 Finish Apples, Remove Highlight Frisket

The sunlight is falling almost on top of the apples and cantaloupe. This means the brightest red of the apple is around the highlight and the top of the apple. The dark shadow (Alizarin Crimson and Viridian) describes the curve away from the light. Cooler purple reflected light bounces up from the tablecloth. Notice the subtle lines of color change, and brush long vertical strokes of color to suggest this. If these strokes look too choppy you can blend them later with a wet brush. Paint the cast shadows of the apples. After comparing the value to the dark apples darken the shadow on the melon. Remove the frisket on the apples' highlights.

4 Finishing Touches

Soften the edges of the highlights with a damp brush and adjust the shadows and edges of the apples. Finish the cantaloupe's dimpled texture. Lighten and fade the texture as it turns to the light and paint it closer together and more elongated as it rolls around the back of the melon.

DEMONSTRATION

Pineapple

I chose to paint a pineapple for its complicated pattern, intriguing textures and variety of colors. Note how its spiny blocklike shapes spiral around the body of the fruit.

Color Palette	
Aureolin Yellow	New Gamboge
Burnt Sienna	Rose Madder Genuine
Cadmium Red	Viridian
Cobalt Blue	Winsor Blue

1 Paint Background and First Washes

Transfer the drawing to watercolor paper then use orange for the first background wash. The tabletop gets a bright yellow-orange underpainting (New Gamboge and Rose Madder Genuine). Locate the centers of the spines with Cadmium Red and yellow dots. Paint in the pale yellow surrounding them with Aureolin Yellow modified with a little Rose Madder Genuine and Cobalt Blue. As you begin the leaves, notice the brightest warm yellow-green areas are where the sun passes through the transparent leaves. The sunstruck leaves are a cooler pale blue. The highlighted top leaves are a warmer blue so use a tint of Winsor Blue. The bottom leaves are a cooler Cobalt Blue. Add a few spots of your darkest leaf values to compare to these mid-values.

2 Background Glaze and Mid-Values

Paint a thin wash of Cobalt Blue over the orange background, making it darker at the bottom. Mid-value greens go around the yellow spines of the pineapple. Paint cool and warm mid-values on the leaves. Use Burnt Sienna and Cadmium Red to paint the heartgrain pattern on the tabletop. Mix a little Cobalt Blue and water with this and gray the grain as it recedes. A darker value (Viridian and Burnt Sienna) covers the shadow side of the pineapple.

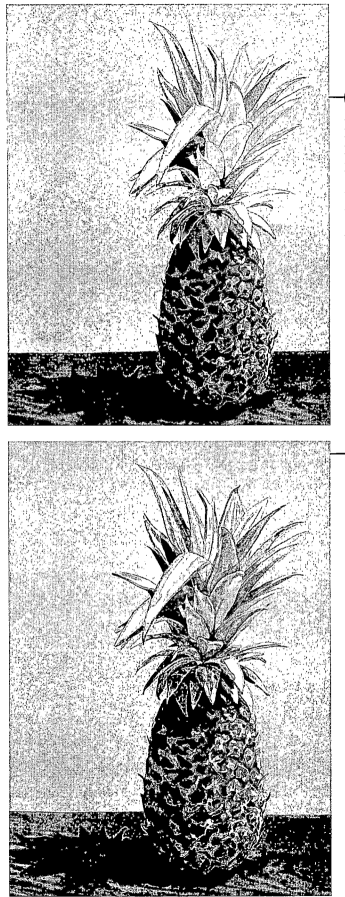

3 Paint the Cast Shadow, Add Color

Paint the cast shadow purple using Rose Madder Genuine and Cobalt Blue with a touch of Aureolin Yellow. This is a transparent mixture so the grain of the table shows through. Treat a few of the sunlit pineapple spines like little portraits and the rest can be suggested. Save the hairlike details coming out of their centers with frisket, then paint some bright yellows and greens. For the dark value that outlines them I use Rose Madder Genuine, Viridian and Aureolin Yellow. I see purple toward the bottom of the pineapple, and I use that color to tone down the lights in the shadow side.

4 Remove Frisket, Finish Leaves

I remove the frisket and can hardly tell the difference. I must have painted around most of the lights anyway. A few spots are darkened and a few spots are lightened by lifting color with a wet brush, and the pineapple body is finished. Again turning our attention to the leaves, keep the ones turning toward the back grayed and indistinct. This will make them roll to the back. The leaves in front are painted in more detail with darks and lights and sharp edges. The underleaves are bluer and cooler while the leaves closer to sunlight are warm.

Strawberries

Reference Photo

I placed these strawberries on an eyelet cloth because I liked the way the dotted eyelet pattern seemed to repeat the dotted highlights on the strawberries. One strawberry was cut open for texture contrast and so I could dribble juice down the front of the cloth. Little messy, unexpected touches make paintings so much more interesting.

1 Paint Background, Save Highlights

A gray-green background and a pale modified Cobalt Blue wash on the cloth set up the white highlights on the strawberries as the lightest value. Save the highlights on the strawberries with frisket. When the cloth has dried paint the eyelet pattern with frisket.

2 Paint Strawberries, Shadows on Cloth

Notice a pattern to the strawberry seeds. Try to paint around them as you build up layers of Cadmium Red, with Alizarin Crimson in the darker areas and orange toward the light.

Color Palette
Alizarin Crimson
Cadmium Red
Cobalt Blue

3 Paint Dark Values and Shadows

Paint dark values and shadows on the strawberries. Add light and dark greens for the stems. Paint the cast shadows. Think of the strawberries' rounded shapes, the bright, saturated red at the top surrounding the white highlights, the darker value through the middle and the reflected light from the tablecloth near the bottom. The darkest value is in the crease where the strawberry meets the table. Remove the frisket.

4 Refine Details

The eyelet design is faded and given shadows in places to blend it into the cloth a little more. Finish the strawberry leaves. Shape the highlights, flattening them as they roll around the edges. Finally, dribble strawberry juice down the front of the cloth.

Peony

Reference Photo

The impact this peony will have depends on the background value to set off its delicate, sunlit petals. I decide to glaze this background and start with Aureolin Yellow. Having the flower heads turned from the viewer adds the interest of the leaves and stem at the back of the blossoms. Sunlight coming from the left and back gives the peony a nice halo of light.

Color Palette
Aureolin Yellow
Cobalt Blue
New Gamboge
Rose Madder Genuine

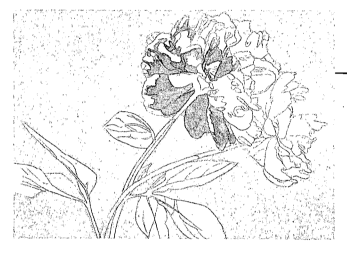

1 Paint First Background Wash, Begin Flowers
Make a careful drawing to map out the lightest areas so you don't lose your way as you paint the delicate washes of the peony blossom. I project a slide and make a "cartoon" to transfer to watercolor paper. Using a delicate triad of Rose Madder Genuine, Aureolin Yellow and Cobalt Blue mix the paint on the paper, letting the colors run and bleed together.

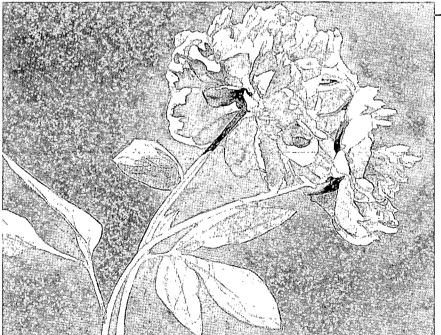

2 Develop Stems and Petals
Paint the preliminary washes for the stems and leaves using Aureolin Yellow for the warm parts and Cobalt Blue for the cool ones. Look for more colors in the petals. For the yellow peony use New Gamboge mixed with Rose Madder Genuine and a little Cobalt Blue. To identify the darkest value for comparisons, paint the dark stem in back of the flowers. Rose Madder Genuine is the next color glaze for the background.

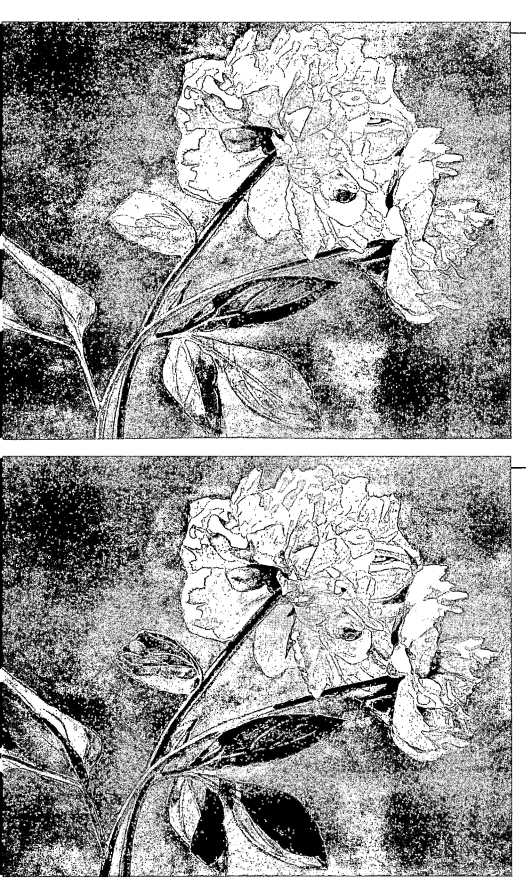

3 Glaze Background, Paint Leaves and Stems

Cobalt Blue is the final color glaze for the background. The mottled effect comes from using 140-lb (300gm/m²) paper that hasn't been stretched, so the washes puddle on the paper. In this case I like the effect. The reddish purple color complements the yellow-green of the leaves and stems. Paint some of the bright greens and yellows of these leaves and stems. A damp brush tip scrubbed back and forth along the stems and other edges will get rid of puddled dark edges from the background.

4 Paint Finishing Touches and Adjustments

Because there is no clear separation of the peonies, darken some of the petals behind the yellow one and bring its stem over all the petals of the pink peony but the lower one. Now they look as though they were nestled together more. Darker shadows are painted on the leaves and the sides of some of their veins. Add a few little darker values to the blossoms to finish.

Iris

I turn to my collection of flower colors to try to capture the brilliant color saturation of this iris. I see several different purples and some orange, Winsor Violet for the bright purple, Winsor & Newton's Mauve for the light purple, Purple Madder Alizarin for the dark red and Permanent Magenta for the brilliant purple-red.

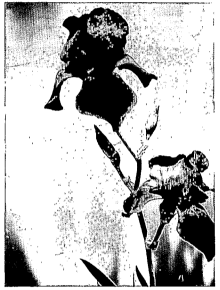

Reference Photo

Color Palette
Aureolin Yellow
Cadmium Red
Cobalt Blue
Grumbacher Thalo Red
Mauve
Permanent Magenta
Purple Madder Alizarin
Rose Madder Genuine
Viridian
Winsor Green
Winsor Violet

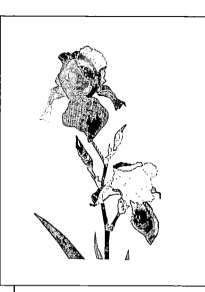

❶ Paint Purples, Stems and Leaves

Paint the flowers using Winsor Violet, Mauve, Purple Madder Alizarin, Permanent Magenta plus Rose Madder Genuine mixed with Aureolin Yellow for the orange. To capture the vivid color of flowers use these colors in their pure form, straight from the tube, diluted only with water. Any mixing happens on the paper as they flow into one another. As you paint the stems and leaves work wet-in-wet keeping cool greens (a mixture of Aureolin Yellow, Cobalt Blue and Viridian) on one side of the form and warm greens (Aureolin Yellow, Rose Madder Genuine and Winsor Green) on the light-struck side. Let them blend on the paper. Think of the stems as cylinders, with cool reflected light on one side, a dark shadow as it turns toward you and sunlight on the light-struck side.

❷ Paint Dark and Mid-Values

Using purples and reds, with very little water added for the darkest values, paint in more dark and mid-values. Paint the dark petal edges while their washes are still damp so they will blend in and not look like outlines. As you build up layers of paint remember placing the darkest value next to the lightest value makes them look darker and lighter respectively.

3 Finish Flowers, Paint Veins

As you finish the iris blossoms continue to use pure unmixed color. I use glazes of Grumbacher's Thalo Red for the red areas and Winsor Violet for the purples. When describing the petals take note where the light strikes them and where they roll away from the light (revealing their purest color) and into shadow. I use a few accents of Cadmium Red (a mid-value) in a few places, the tip of the large petal on the top flower and some touches inside the blossom. Pure colors can be moistened and lifted or diluted without creating mud. As you paint the veins on the flower petals make sure to follow their contours.

African Violet

See how nature puts a little spot of yellow in the middle of intensely purple African violets, just the right amount of their complementary color. Finding the right purple is a challenge. I can't come up with one bright enough so I use Grumbacher's Thalo Red. It's still not right but if everything else is darkened and dulled it may have enough impact.

Reference Photo

Color Palette
Alizarin Crimson
Aureolin Yellow
Burnt Sienna
Cerulean Blue
Cobalt Blue
Cobalt Violet
Grumbacher Thalo Red
Lemon Yellow
Purple Madder Alizarin
Rose Madder Genuine
Viridian
Winsor Green

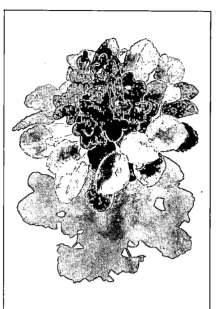

① Paint the Brightest Color and Cast Shadow

Paint the flower centers Lemon Yellow. Grumbacher's Thalo Red is the underwash for the violets. Add water and let the white paper make it brighter. Vary the leaf washes from yellow to green to blue, letting them run together and blend. Use Aureolin Yellow mixed with Winsor Green for a bright green, Aureolin Yellow and Viridian for a gentler green and Aureolin Yellow and Rose Madder Genuine for the yellows. For the cool highlights, use Cobalt Blue and for the touches of warmer blue use Cerulean Blue. The darkest value (Alizarin Crimson and Winsor Green) is added in a few spots so all the values can be compared. Mix up a good amount of Cobalt Blue, Rose Madder Genuine and a touch of Aureolin Yellow and start the cast shadow with the painting turned on its side. Paint from top to bottom, dropping more Aureolin Yellow into the wash as you move down to suggest reflected color.

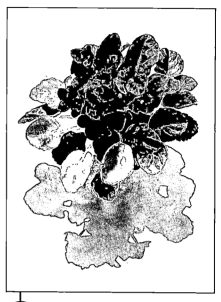

② Paint Darker Values

Paint the darker flower values using pure violets and reds. I break out my tiny tube of Cobalt Violet (tiny, because it's so expensive) and use that over the Thalo Red for the shadows of the light-struck petals. A few spots of dark Purple Madder Alizarin give me an idea of the darkest petal value. The darkest leaf value is a mixture of Viridian and Burnt Sienna. While this is still wet, drop in some lighter green (Aureolin Yellow and Viridian) for the lighter areas of the dark leaves. Notice how the dark leaf values begin to make the flowers seem brighter.

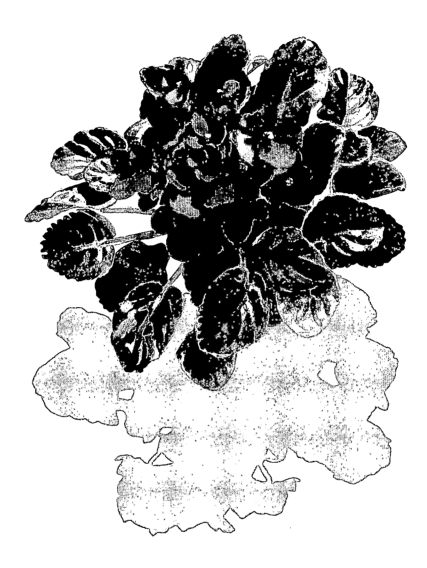

3 Finish Petals and Leaves

Paint the flowers more carefully, picking out petals to emphasize and darkening background ones. Give yellow flower centers form with orange shadows. Finish the leaves on the left as you did the ones on the right with warm and cool darks and lights. Darken and sculpt the pink leaf stems.

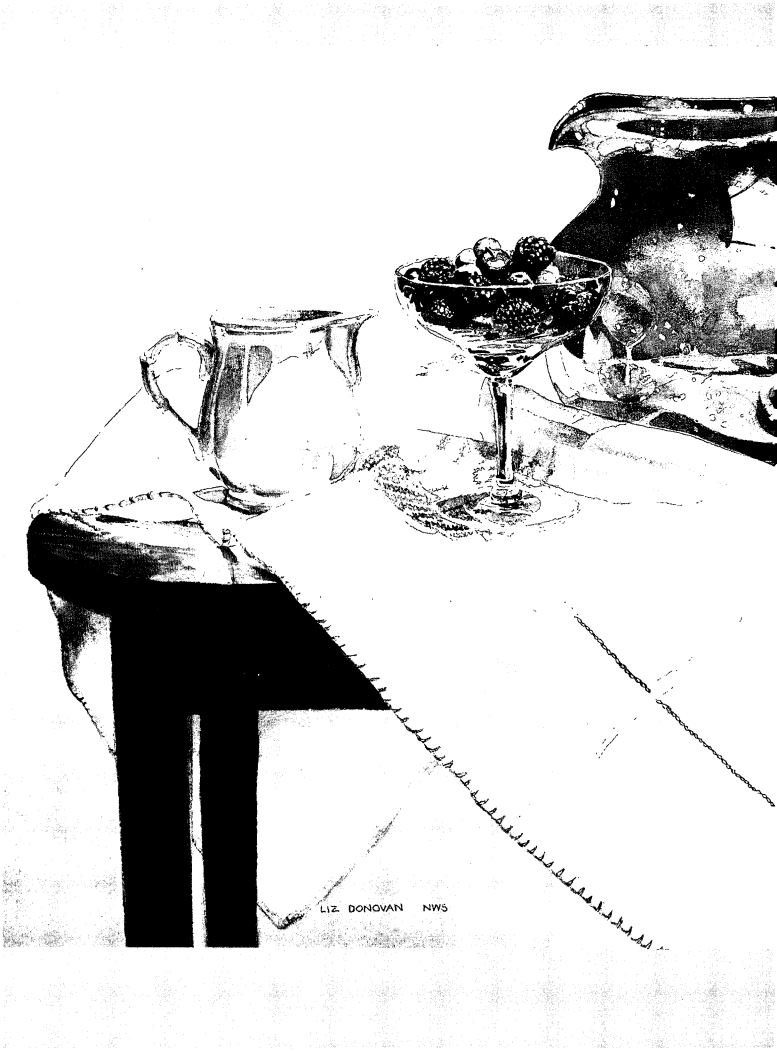

LIZ DONOVAN NWS

CHAPTER SEVEN

Putting It All Together

This chapter shows how, after much trial and error, I have become comfortable working. I don't believe in being over-fastidious. Leaving in painterly brushstrokes, drips and bleeds shows an artist's hand at work. I seldom use a brush smaller than no. 5. Perhaps you'll want to adopt some of my methods, some of other artists and develop some of your own. This will become your own personal style.

COBALT PITCHER, 17" × 26" (43cm × 66cm)

Tackling Complex Subjects

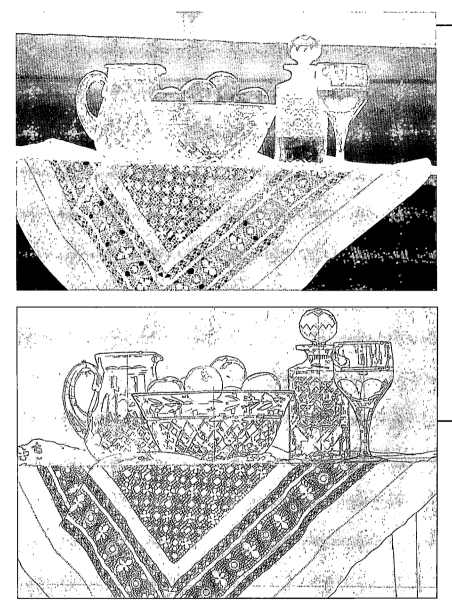

Color Palette
Alizarin Crimson
Aureolin Yellow
Cadmium Red
Cobalt Blue
Rose Madder Genuine
Winsor Green

1 Arrange Your Setup
Deciding on a specific approach and solving design or lighting problems are enjoyable preliminary steps in the painting process. Though the reference slide of the setup shown here is not good, it gives enough information to proportion the objects and place the light correctly. I arranged the still life for *Crystal and Plums* in front of a large glass door. Feeling that a dark background would dramatically enhance the impact of this painting, I placed a large black board behind the items in the setup. The daylight flooded in over the top of the board, creating a special sparkle in the crystal glassware. Once you are satisfied with your overall arrangement, take a series of slides at close range.

2 Correct Camera Distortion
Choose a slide that clearly represents your view of how the piece should look, and project the image onto Trazon tracing paper. This is drafting paper with a blue grid used to correct camera distortion and perspective. I chose to add an extra plum on the left to balance my composition.

3 Transfer Corrected Drawing

Transfer the corrected drawing to 300-lb (640gm/m²) cold-press watercolor paper (corrections are possible without visibly damaging the surface of this heavy paper as described on page 22). Place tape around all four sides for a clean edge. Use graphite transfer paper between the watercolor paper and the original drawing to trace over the image using only the lines you need to help you find your place in the painting. Now paint the background with a mixture of Alizarin Crimson and Winsor Green. The rich, dark value serves as a great contrast for the gleaming glass.

4 Start the Cloth

Paint a light Cobalt Blue wash over the front of the lace cloth to create a cool underlayer, and let it dry completely. Paint over it with a darker wash of Cobalt Blue, Rose Madder Genuine and Aureolin Yellow. Describe the flow of the cloth and develop areas of interest by varying the color intensity.

Frisket Applied

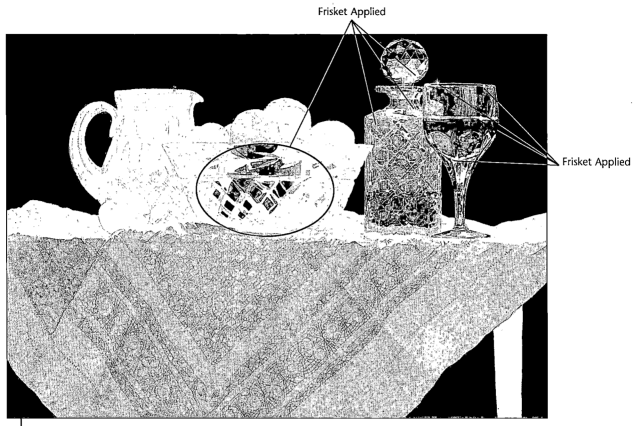

Frisket Applied

5 Crystal and Plums

Capturing the true look of sparkling, faceted crystal comes from maintaining absolutely pure highlights and concentrating on the images reflected in the glass surfaces. Apply liquid frisket to the white areas to preserve highlights. Shown here, the frisket appears as a gray color (see the whites ultimately preserved on page 115). I like Pebeo drawing gum, a liquid frisket thinner than most standard products. It can be applied in fine lines when necessary. Let it dry, then with a mixture of Alizarin Crimson and Winsor Blue paint in some of the darkest values of the plums showing through the crystal, the wine in the decanter and the wine in the wine glass. This gives you the darkest value against which to judge other values. Now you can paint the other abstract shapes of the crystal facets by layering more intense versions of the colors found in the lace cloth. Let dry. Remove frisket. Paint the frosty blue tint of the plums. Use warm red tones for the front plum placing it in front of the cooler, darker ones behind it. Using the same reds, yellows and blues retains the overall color harmony. Keeping the stem sharp and light-struck helps it come forward. A halo of light separates the plums from the background.

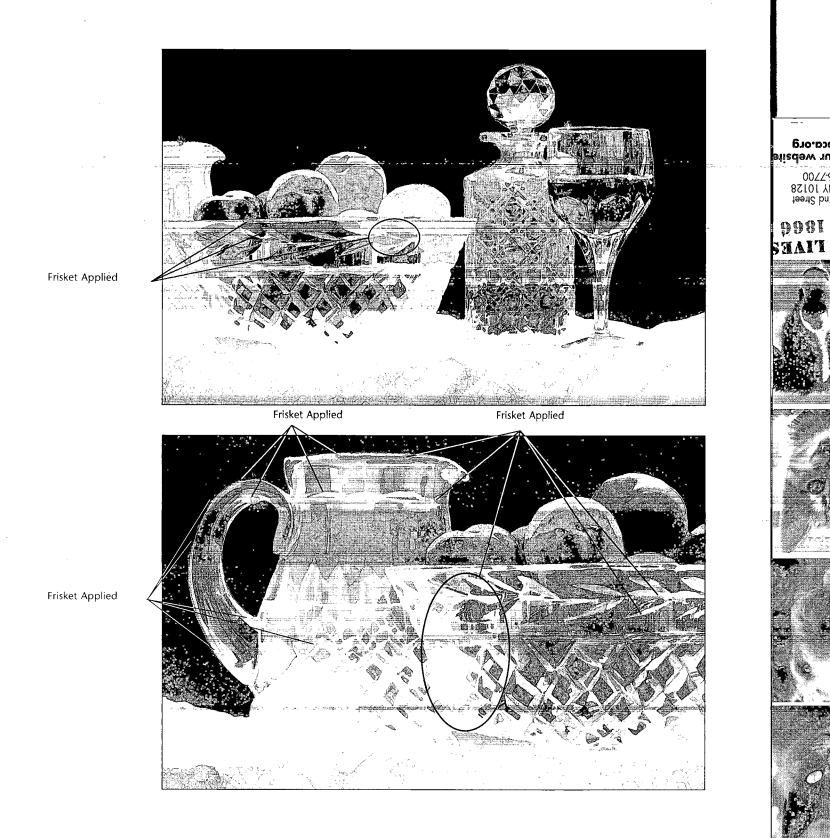

Frisket Applied

Frisket Applied

Frisket Applied

Frisket Applied

Frisket Removed Frisket Removed

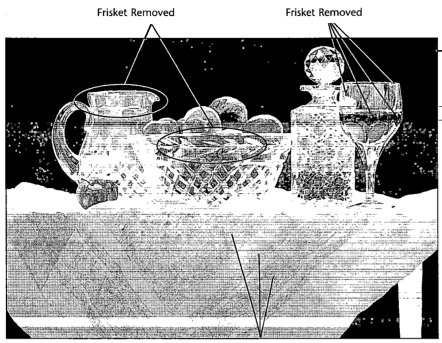

Frisket Applied

6 Begin Lace Pattern
Apply frisket to the open latticework pattern of the cloth and let dry completely.

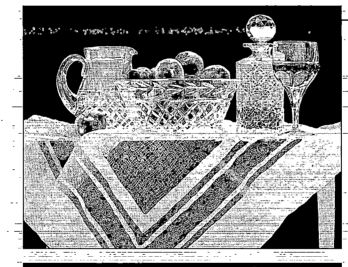

7 Apply Darker Washes
Apply darker washes of various Alizarin Crimson and Winsor Green mixtures to the openwork areas of the cloth.

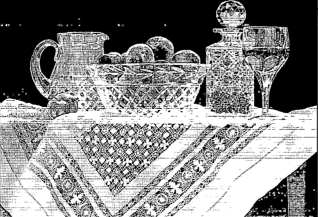

8 Remove Frisket, Shade
When the frisket is removed, the lace looks more natural than if you had painted each tiny hole individually. Add shading for more depth and interest.

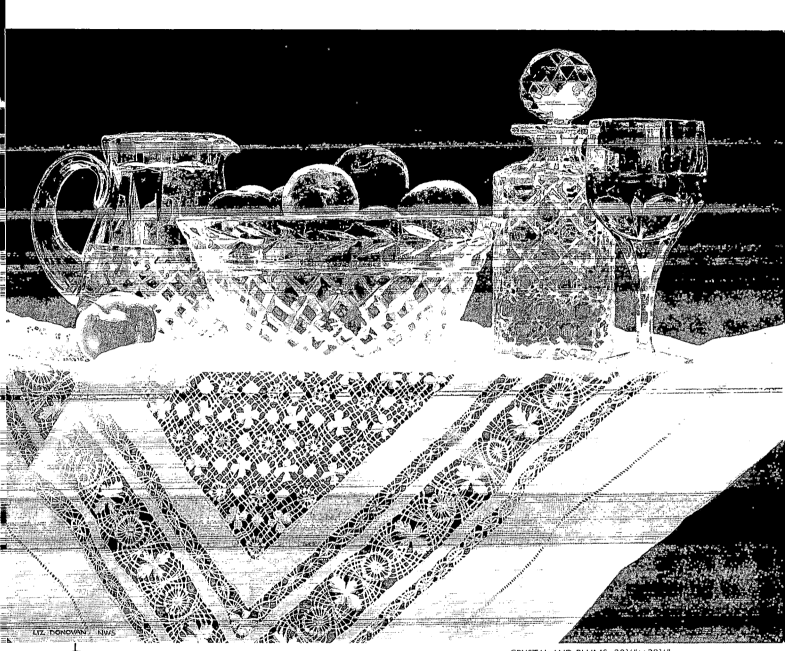

9 Add Finishing Touches

It is vitally important to feel as though you always have options; you can change direction when necessary. I decided at this late stage that the table leg on the right side of the painting was superfluous and detracted from the composition. I also felt the painting needed some strong additional color, so I added accents of pure Cadmium Red along with other finishing touches.

CRYSTAL AND PLUMS, 20¾" × 28¾"
(53cm × 73cm)

Painting Glass and Ceramics

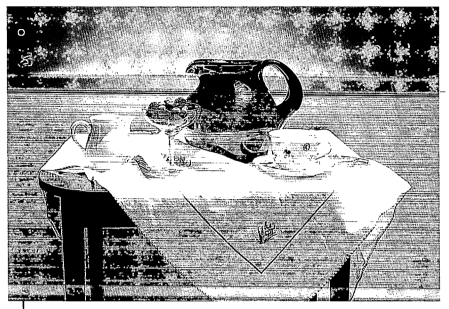

Color Palette
Alizarin Crimson
Aureolin Yellow
Burnt Sienna
Cobalt Blue
Grumbacher Thalo Blue
Grumbacher Thalo Crimson
Rose Madder Genuine
Ultramarine Blue
Winsor Blue
Yellow Ochre

1 Arrange Setup
Take many slides of your setup, both close-ups and full views. I picked a slide that most captured the look of reflected blue I was after. This painting will be kept quite neutral and light in value except for the brilliant blue glass of the pitcher, the red raspberries and the blueberries. Because I've set up for backlighting, some sunlight passes through the pitcher and drops brilliant blue color into its cast shadow, while light striking the pitcher has a wonderful "starry night" quality of little pinpoints of light flickering on the deep blue glass. This bouncing color is echoed by the berries and cloth.

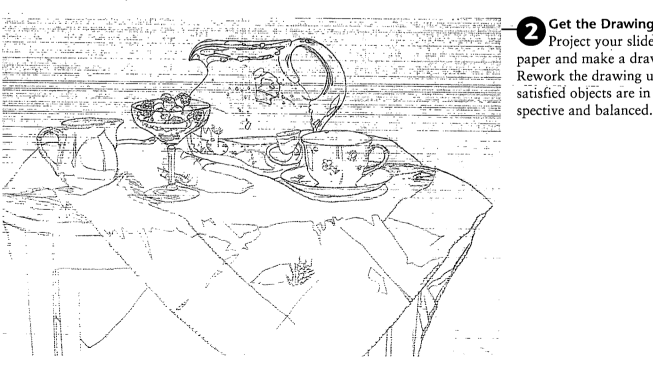

2 Get the Drawing Right
Project your slide onto grid paper and make a drawing of it. Rework the drawing until you are satisfied objects are in proper perspective and balanced.

3. Paint the Background

Transfer the drawing to Arches 300-lb (640gm/m²) watercolor paper as described on page 22 and tape the sides. Mix a generous amount of well-diluted Rose Madder Genuine, Aureolin Yellow and Cobalt Blue wash. Using a 1-inch (25mm) brush, start in the lower left corner and pull one continuous long bead of paint up and around the entire background, ending at the lower right. You must work quickly and never brush back into the wash as streaks and uneven paint layers will occur. Fill in the spaces inside the handles and under the tablecloth after finishing the larger wash. Start with the paler washes and colors, because if any dark or intense colors (such as those of the table legs or the blue pitcher) were already in place, they could bleed into the background wash as it is applied.

4. Layer Color Washes

Over a thoroughly dry tint of Aureolin Yellow, paint shadows to describe the folds of cloth using another mixture of Aureolin Yellow, Rose Madder Genuine and Cobalt Blue. Drop reflected color into the shadows in places. Because the background is now completely dry, it can be wet with pure water without disturbing the gum arabic of the underlying paint. Lay down another, darker wash of background color behind the table to set off the tablecloth.

5 Save Lights With Frisket
Turning your attention to the pitcher, dampen the area where a skylight is reflected and drop a dollop of liquid frisket into it. This makes the frisket diffuse into the damp paper to simulate the effect of the reflected sun. Dots of frisket also save the little pinpoints of light on the surface of the pitcher.

6 Develop the Blue Pitcher
Use a mixture of Ultramarine Blue and Winsor Blue as underpainting for the pitcher, with violet reflections here and there. Other objects are reflected in interestingly distorted ways. After the underwash dries, add more dots of frisket that will become light blue dots of light after further washes are applied.

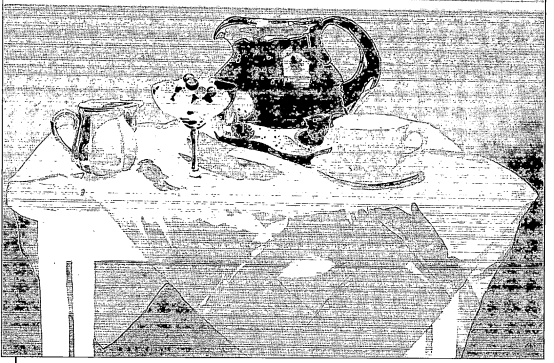

7 Underwashes for Other Objects
Save highlights with dots of frisket on the lip and handles of the cup and small pitcher, the glass and on individual raspberry bumps. The first wash to define the contours of the smaller pitcher is a mixture of Rose Madder Genuine, Cobalt Blue and Aureolin Yellow. Subtle color changes are exaggerated. Use a bluer underwash for the cup with reflected yellow at the bottom. To save the sharpness of the clear glass of berries, paint directly, without underwashes. A light Cobalt Blue wash grays down the corner of the tabletop.

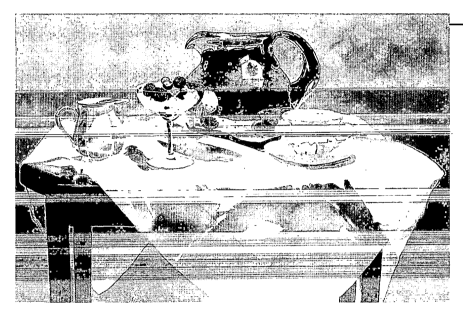

8 Add More Color and Highlights

Apply more frisket for subtle cup highlights, so you can be free with overwashes. Use a mixture of Alizarin Crimson and Ultramarine Blue with a bit of Aureolin Yellow for the red underpainting of the table. The tabletop is a more yellow version of this, with Yellow Ochre, Alizarin Crimson and some Cobalt Blue where the white cloth is reflected. Blot with tissue to save these highlights. Add more berries, working all over to compare values.

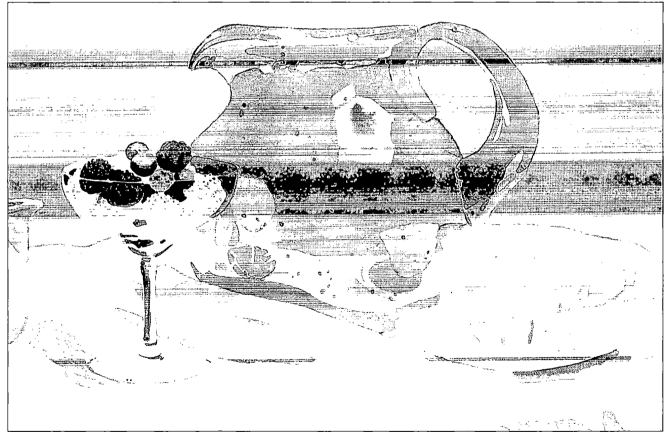

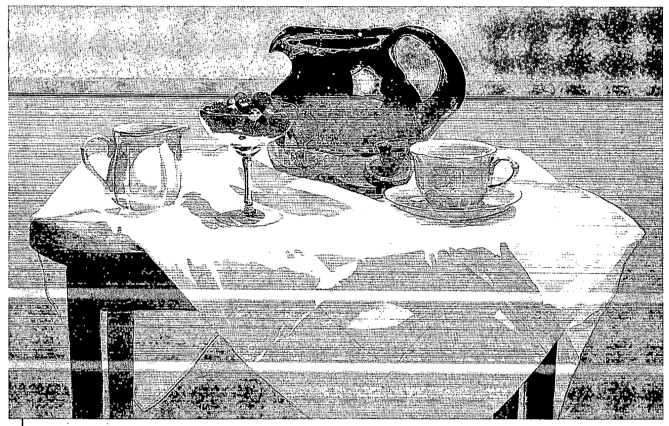

9 Finish the Pitcher

Use a mixture of Grumbacher Thalo Crimson and Thalo Blue to finish the brilliant, transparent blue of the pitcher. Remove the frisket. Adjust some spots. Paint berries individually, as if they were little portraits. Wash Rose Madder Genuine, Aureolin Yellow and the Cobalt Blue shadows over the cup. After that dries, thoroughly remove the frisket. Apply another light wash to soften the highlight. Paint red lines around the lips of the cup and saucer. Remove the frisket highlight.

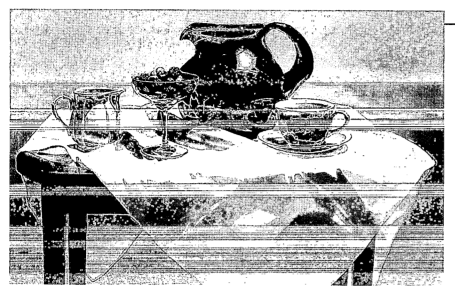

10 Shadows and Reflections

Apply darker shadows to the cup. Darken table legs, and suggest some grain with a mixture of Ultramarine Blue and Burnt Sienna. Wet the fold near the blue pitcher; drop in some blue reflections and darker shadows. The glass of fruit gets some sharp darks to finish. More warm tones are painted on the tabletop, leaving a grayed-down white for the cloth reflection. Check the value of the cloth against the porcelain cup and small pitcher. Darken the cloth by wetting it and dropping in some cooler shapes.

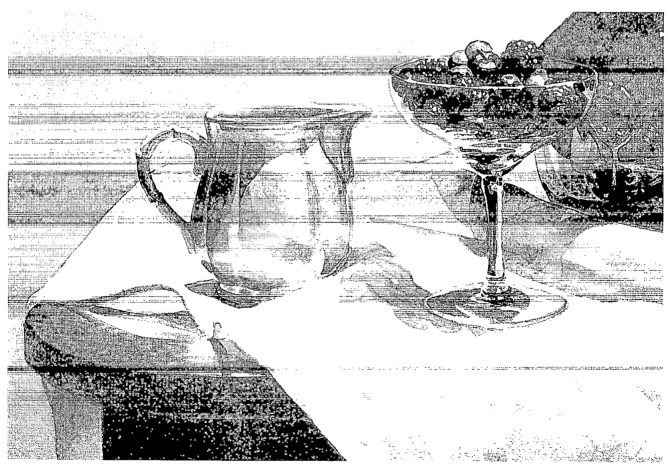

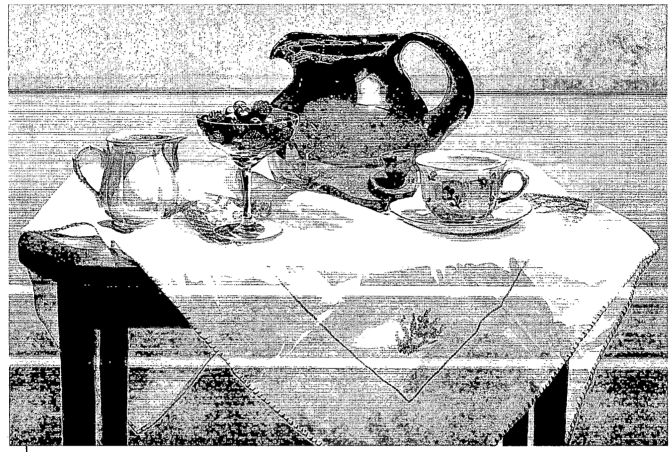

11 Add Details

Add the cup design and patterns of cross-stitching.

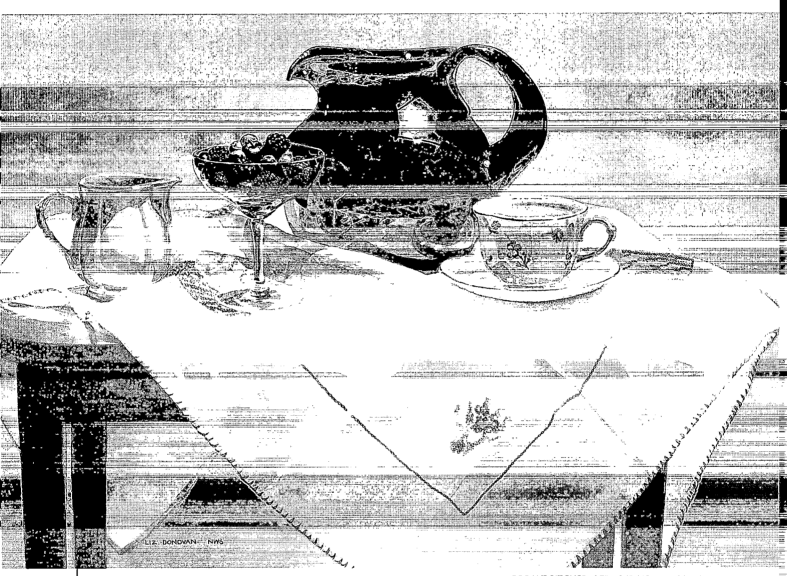

COBALT PITCHER, 17" × 26" (43cm × 66cm)

12 **A Little Fine-Tuning**
Put the painting where you can't avoid looking
at it. After awhile you'll notice things that need atten-
tion. I added more folds to the top of the cloth, and
a darker shadow where the large wrinkle rolls. Soften
outlines with a wet Incredible Nib. This step is best
left for last, because it stirs up the surface of the paper.

Painting Metal

<div style="border:1px solid">

Color Palette
Aureolin Yellow
Burnt Sienna
Cadmium Red
Cadmium Yellow
Cerulean Blue
Cobalt Blue
Raw Sienna
Rose Madder Genuine
Ultramarine Blue

</div>

1 Plan Your Composition

These objects were chosen for their color and texture. The soft peaches contrast with the hard shiny metal of the brass tray. I'll push the orange colors I see in the tray to complement the pure Cerulean Blue in the cloisonné vase, the center of interest. Blues and oranges will also be emphasized in the quilt, fruit and flowers. Circles and triangles are used for compositional effect. Take many slides and project your favorite onto grid paper. Make your drawing and rework it until you're satisfied. Difficulty drawing drawer pulls? Draw half on a piece of tracing paper, fold it in half and trace the other side so they will be symmetrical. Transfer the drawing to watercolor paper as described on page 22.

2 Background

Begin building the background with washes, starting with Aureolin Yellow.

<div style="border:1px solid">

Use Familiar Objects
Reference photographs or slides do not provide all the information needed about surfaces and textures. It's better to work with familiar objects and have them in front of you as you paint them.

</div>

3 Apply More Thin Washes

The Aureolin Yellow wash must be thoroughly dry before applying the next background wash, Rose Madder Genuine, or the color will be disturbed. Avoid going back over brushstrokes as you apply these layered washes. A thin wash of Burnt Sienna and Cobalt Blue on the quilt tones the white paper.

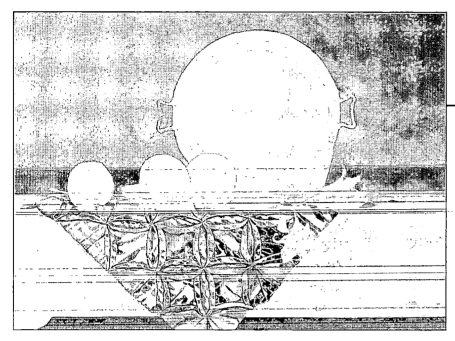

4 Painting the Folds of the Quilt

Wash the background with Cobalt Blue diluted to just a tint. Paint the quilt folds using varied mixtures of Burnt Sienna, Raw Sienna, and Cobalt Blue as red, yellow and blue. Vary the shadow shapes for a more interesting design.

5 Compare Values and Color Intensity

Paint the design over the quilt folds first to be sure the reds used for the daylilies are more intense than those used on the quilt. Throughout the painting process, check value relationships—rework, darken, brighten or modify areas.

Sunny Yellow First

Yellow glazed over other colors muddies them, but applied first it glows through subsequent colors giving a feeling of sunlight.

6 Begin Peaches

The background shadow of a beam I planned to use for compositional purposes turns out a little too dark here, but I'll tackle that later. Apply pure color to the peaches using Cadmium Yellow, Cadmium Red and Aureolin Yellow, keeping the fuzzy look by putting the color down wet-in-wet.

Pure Color

Used directly from the tube and diluted only with water, pure color has not been mixed with other colors.

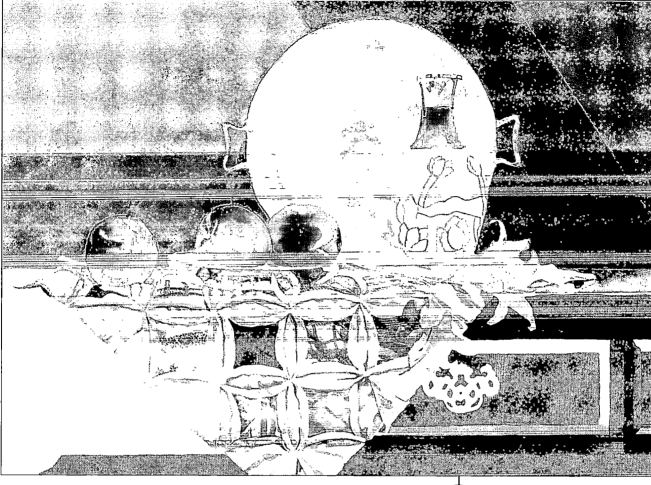

7 Paint Brass Objects

Repeat all three background washes (Aureolin Yellow, Rose Madder Genuine, Cobalt Blue), drying each between application, scrubbing the shadow to lighten it as you apply them. Underpaint brass objects using yellows and oranges. Float other reflected colors into this wash. Cerulean Blue best describes the blue of the vase, so put some in the most brilliant areas. Apply washes to the right side of the table. The sunlit front is a yellowed red, and the shadowed parts pick up a blue-gray cast.

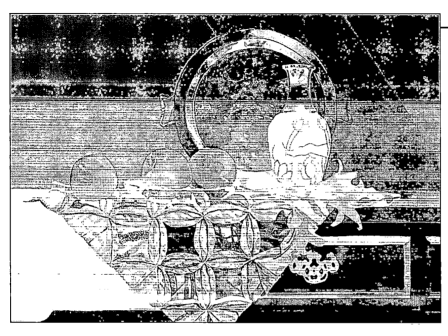

8 Observe Objects Closely
Paint the brass tray with mixtures of Aureolin Yellow and Raw Sienna. Modify this combination with Cobalt Blue, and add even more Cobalt Blue for the dark areas. Drop oranges, Cerulean Blue and other colors into the wet underpainting where they reflect on the shiny surface.

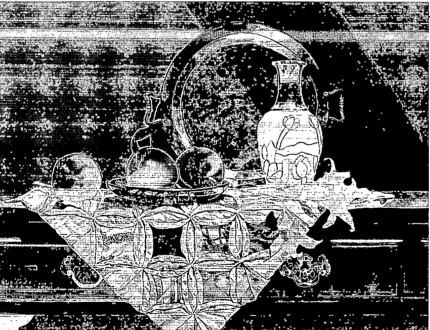

9 Finish Brass, Develop Table
Another wash of light yellow color blends areas that suggest the pounded metal tray. Darken where the shadows fall with a mixture of Aureolin Yellow, Raw Sienna and Cobalt Blue. Finish the brass dish in the same way. Dampen the diagonal shadow on the wall and float color in. Add some grain to the drawer. To round the drawer molding, a bright red wash goes on top of a water wash that has dried somewhat, blending into the highlights and graying into the darker color on bottom. Add a mixture of Ultramarine Blue and Burnt Sienna for shadow. For the bright areas on the slightly damp brass handle, mix Cadmium Red, orange and Aureolin Yellow; and for the dark areas, Raw Sienna and Cobalt Blue. Begin to paint the left part of the table as you did the right side.

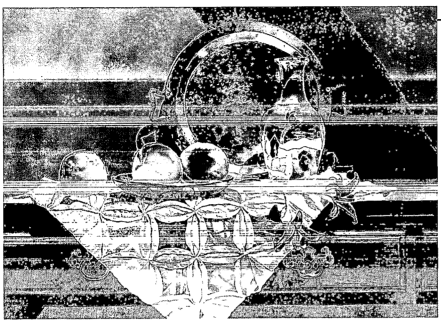

10 Layer Color

Apply layers of bright reds, pinks and Cerulean Blue to develop the vase, carefully preserving white highlights. Paint deeper color and grain on the left side of the table, and darken the drawer pull with Raw Sienna and Cobalt Blue. After that dries, apply the left side shadow.

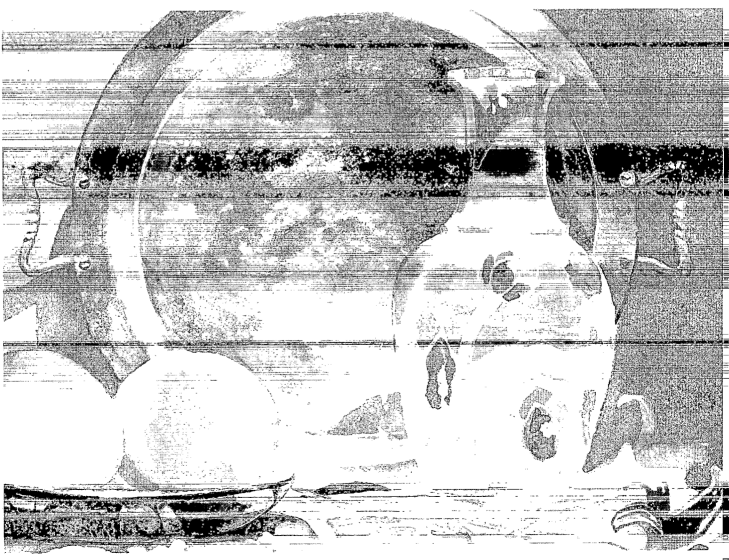

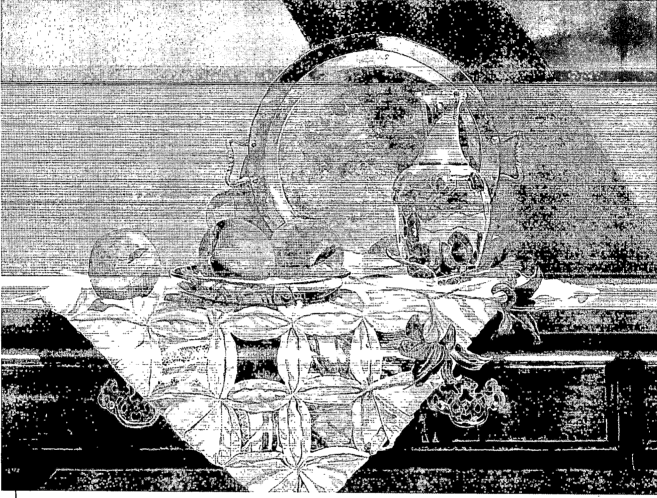

11 Soften Edges, Adjust Values

Work all over, adjusting values and putting in more detail: dark and brilliant reds for the lilies, darker glazes of color on the vase. The peaches get more soft washes of Rose Madder Genuine and Aureolin Yellow. Keep edges soft by nudging these washes into the background with a dry, soft brush. A wash of water blotted with a tissue helps soften the color washes on the peaches. Soften the sides of the vase using a moistened Incredible Nib to further give the illusion of it rolling into the background. Keep the vase design sharp in the foreground and muted as it rolls back.

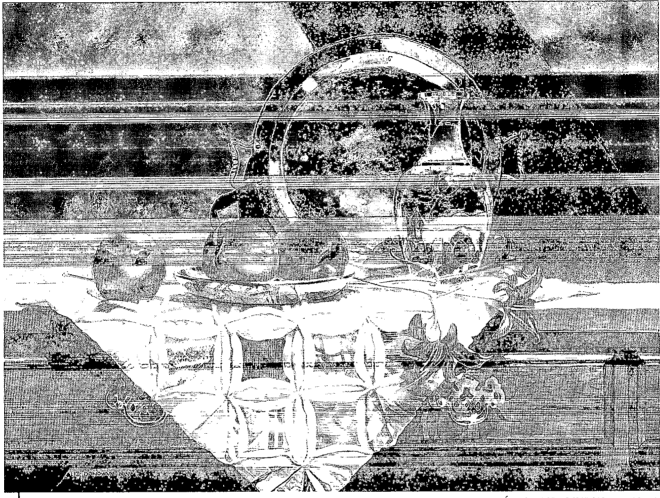

CLOISONNÉ VASE, 19" × 25¾" (48cm × 65cm)

12 Finish Peaches and Other Areas

While the peaches themselves have light and dark markings, their round forms must also be considered, as well as the light reflected on them from the tablecloth and brass dish. This reflected light is several values darker than the sunstruck yellow that is the lightest part of these peaches. The left stem is their darkest dark, and contrasts nicely against the light yellow. Exaggerating strong contrasts in your paintings gives them visual impact.

Painting Fruit and Flowers

1 Plan Your Composition
The dull, mineral-stained pot holding this gloxinia contrasts with the shiny table surface. Combining smooth and rough surfaces and textures in your paintings adds interest. The lemon peel hangs over the edge of the table and breaks up that long parallel line. A stray flower ensures things don't look too neat. The purple of the gloxinia complements the yellow of the lemons.

Color Palette

Alizarin Crimson
Aureolin Yellow
Burnt Sienna
Cadmium Red
Cadmium Yellow
Cobalt Blue
Lemon Yellow
Light Red
New Gamboge
Permanent Magenta
Rose Madder Genuine
Ultramarine Blue
Winsor Blue
Winsor Green
Yellow Ochre

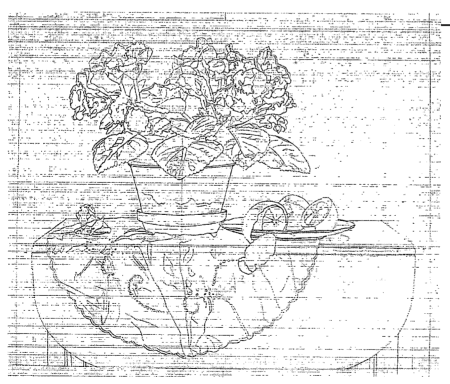

2 Correct Distorted Perspective
When working from slides or photographs, you must still correct distortion. My drawing is done on graph paper from a slide projection, so I can plot the curves of the table to make sure the sides are equal. The ellipses of the flower pot and plate are made parallel to the horizon line, using simple one-point perspective for the composition. Transfer your drawing to watercolor paper as described on page 22.

Bloom
A feathered blotch caused by a wet wash running back into an almost dry wash.

Bloom

3 Paint the Background

Apply the background wash first. That way, working from back to front, you end with the most sharply focused part of the painting. I mix a wash of Aureolin Yellow, Rose Madder Genuine and Cobalt Blue, leaning toward the yellow to complement the purple gloxinia. Another, darker wash is mixed, leaning toward gray, for a darker background behind the table. Using a large, soft brush, begin with the darker wash at bottom left. Working quickly and turning the paper, switch to the lighter wash as you come up behind the arrangement and back to the dark as you drop behind the right side of the table. In my painting, unfortunately, a puddle of paint ran back into the almost-dry wash from the upper right edge of tape, causing a *bloom*. This could have been prevented by draining any puddles around the edge of the tape with the corner of a piece of tissue. In this case the bloom is small and close to the edge so a mat will cover it.

4 Reflected Light and Shadows

Apply an underwash of blue-gray (Aureolin Yellow, Rose Madder Genuine, Cobalt Blue) to the cloth where it is in shadow. Drop pure yellow under the plate as a reflection of the lemon peel, and Burnt Sienna under the flower pot. When the initial shadow on the cloth is dry, apply frisket to the design and scalloped edges.

Mix Plenty of Wash

Mix more of a wash than you think you need! There is nothing so distressing as running out before you're finished.

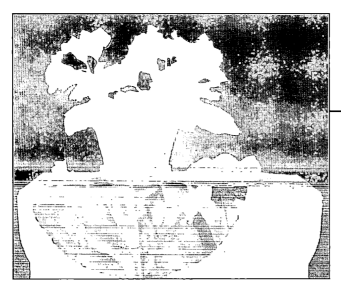

5 Glaze Cloth Shadows
After initial washes are dry, apply crisp shadows to suggest the creased linen of the cloth. Wait for drying time, then add a water wash to prepare the surface for a warmer, darker wash to unify the background gradation behind the table.

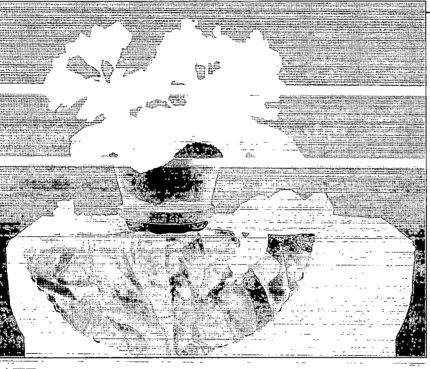

6 Begin the Pot
The dark-valued clay pot is something of an anchor to hold everything down. Judge the weight of everything else against it. Burnt Sienna, Yellow Ochre and Cadmium Red are washed brighter on the light side, with more Cadmium Red, and the middle modified with Winsor Green to darken and dull it. Apply a light tint of Cobalt Blue where the white salt stains appear.

7 Complete the Pot
Light Red is used with Winsor Green for the very dark stains on the pot. Keep the pot dark in the middle and light on the sides, as it is backlit. Cadmium Red appears in the transition from light to dark.

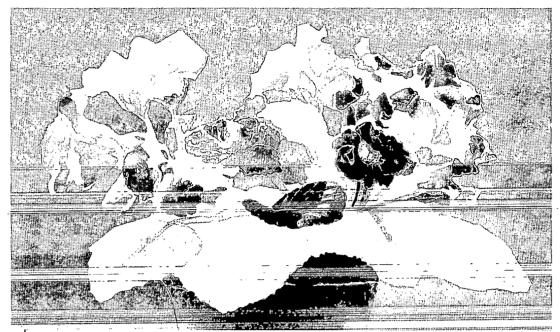

8 Begin Flowers and Leaves

Pure color is needed to capture the vivid, intense color of the flowers. Keep many exotic reds, pinks and purples on hand if you want just the right color for your flowers. Here I use Winsor & Newton Permanent Magenta. These flowers are transparent, with light passing through the pet-als from behind. Where they are in shadow, a delicate, transparent glaze (Aureolin Yellow, Rose Madder Genuine and Cobalt Blue) is used, pushing one color or another for variety. Use Aureolin Yellow and Winsor Blue for the brilliant greens and Cobalt Blue and Aureolin Yellow modified with Alizarin Crimson for the darker areas. Leaves have a bluish cast to the light-struck part. Keep edges closest to you sharp and softened as they go back to make them appear to recede. When one flower and leaf are finished, I am comfortable enough with the value and underpainting to proceed with the others.

9 Give the Table Its First Glazes

The underglaze on the front of the table is Alizarin Crimson, Yellow Ochre and Ultramarine Blue. On top, where sunlight hits it, I add Cadmium Yellow to the mixture.

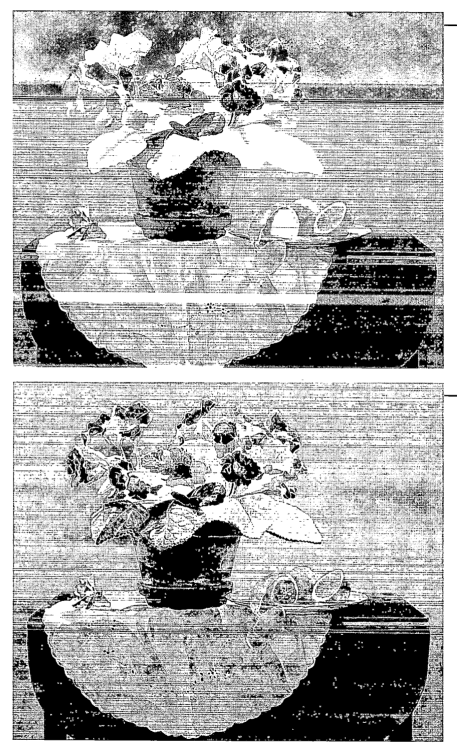

10 Begin Lemons and Plate
The tooth of cold-press watercolor paper lends itself to painting lemons. Start with a light Lemon Yellow wash. A drier mixture of Cadmium Yellow and purple skips over the paper, leaving the texture of the lemon peel. White highlights have a circular pattern around the light spot. Layer more yellow values on, light to dark, until it looks right. A few brushstrokes are all that is needed to suggest the plate.

11 Adjust Table Values
Strokes of Ultramarine Blue and Burnt Sienna, applied horizontally on the table to suggest grain, are blended with a wet brush. When dry, wash Yellow Ochre over the table. Darken the shadowed part of the cloth to make the lemon peel pop out, and to sharpen the sunlit areas. Add some New Gamboge to the lemons, as it is a more transparent yellow than Cadmium and works better here.

Tooth
This refers to the textured surface of cold-press watercolor paper affecting how it holds paint.

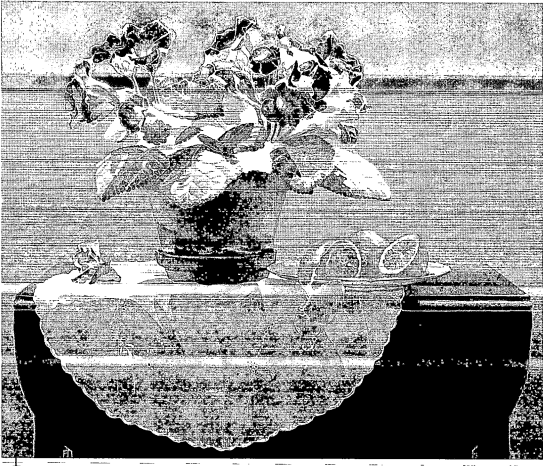

12 Antique the Wood

Another wash of Ultramarine Blue and Burnt Sienna with some Alizarin Crimson darkens the table further. More streaks go on for the grain, with a darker shadow under the cloth. When this is almost dry, blend streaks with a wet brush. This is a case where blooms and mottling of painting wet-in-wet pigment becomes useful for antiquing the wood. Remove the frisket from the cloth design. Develop flowers and leaves using the methods described in Step Eight.

GLOXINIA AND LEMONS,
20½" × 24¼" (52cm × 62cm)

⑬ Finish

Finish the gloxinia, considering them as a mass, not individual flowers and leaves. Background edges of flowers and leaves are teased away using a damp Incredible Nib, while closer edges are kept sharp to make them come forward. The cloth gets more crisp shadows. Its design is muted and sculpted with shadow color (a mixture of Rose Madder Genuine, Aureolin Yellow and Cobalt Blue). Now put your painting where you have to look at it repeatedly. Rework areas that bother you. Put some greens on the lemons, giving them more of a value range, and put a warm neutral tone over most of the flower on the table to give it a solid look.

Gallery

BRASS BUCKET OF CATTLEYA, 32"×44" (81cm×112cm)
Collection of Mr. and Mrs. Brian Anderson.

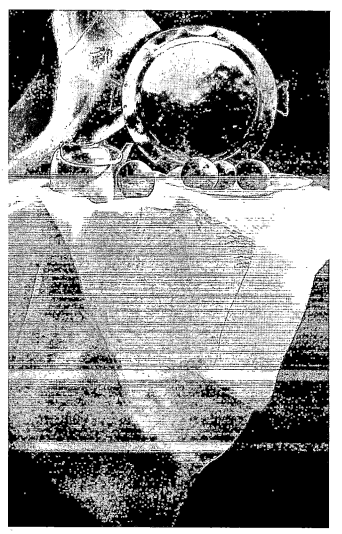

BRASS AND PLUMS, 26"×40" (66cm×102cm)
Private collection.

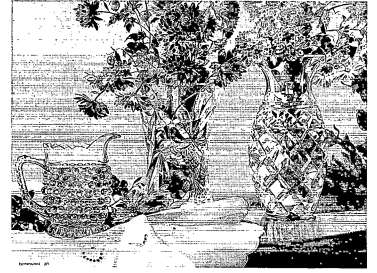

CRYSTAL AND MUMS, 15"×20" (38cm×51cm)
Private collection.

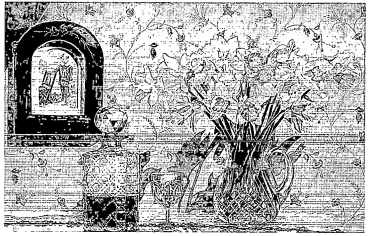

DAFFODILS AND CUT GLASS, 33"×38" (84cm×97cm)
Private collection.

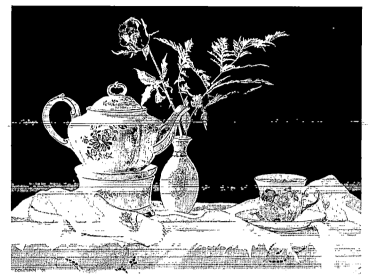

TEAPOT AND ONE ROSE, 16¾″ × 21¾″ (43cm × 55cm)
Collection of Robert Adams.

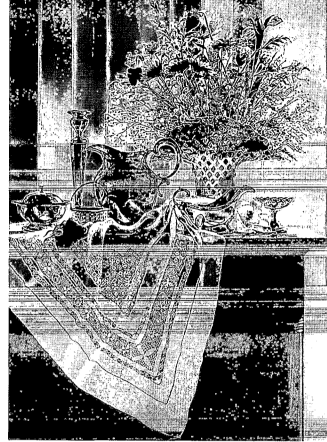

TARNISHED SILVER, 41″ × 29″ (104cm × 74cm)
Private collection.

MUMS IN BERRY BUCKET, 15″ × 15″ (38cm × 38cm)
Collection of Mr. and Mrs. Carl D. Jones.

OLD GLASS, 15″ × 20″ (38cm × 51cm)
Collection of Mr. and Mrs. Hamish Osborne.

Index

More Great Books for Beautiful Watercolors!

Painting Watercolor Portraits—Create portraits alive with emotion, personality and expression! Popular artist Al Stine shows you how to paint fresh and colorful portraits with all the right details—facial features, skin tones, highlights and more. *#30848/$27.99/128 pages/210 color illus.*

Step-By-Step Guide to Painting Realistic Watercolors—Now even the beginning artist can create beautiful paintings to be proud of! Full-color illustrations lead you step by step through 10 projects featuring popular subjects—roses, fruit, autumn leaves and more. *#30901/$27.99/128 pages/230 color illus.*

Painting Greeting Cards in Watercolor—Create delicate, transparent colors and exquisite detail with 35 quick, fun and easy watercolor projects. You'll use these step-by-step miniature works for greeting cards, framed art, postcards, gifts and more! *#30871/$22.99/128 pages/349 color illus./paperback*

The North Light Illustrated Book of Watercolor Techniques—Master the medium of watercolor with this fun-to-use, comprehensive guide to over 35 painting techniques—from basic washes to masking and stippling. *#30875/$29.99/144 pages/500 color illus.*

Capturing Light in Watercolor—Evoke the glorious "glow" of light in your watercolor subjects! You'll learn this secret as you follow step-by-step instruction demonstrated on a broad range of subjects—from sun-drenched florals, to light-filled interiors, to dramatic still lifes. *#30839/$27.99/128 pages/182 color illus.*

Creative Light and Color Techniques in Watercolor—Capture vibrant color and light in your works with easy-to-follow instruction and detailed demonstrations. Over 300 illustrations reveal inspiring techniques for flowers, still lifes, portraits and more. *#30877/$21.99/128 pages/325 color illus./paperback*

Watercolorist's Guide to Mixing Colors—Say goodbye to dull, muddled colors, wasted paint and ruined paintings! With this handy reference you'll choose and mix the right colors with confidence and success every time. *#30906/$27.99/128 pages/140 color illus.*

Splash 4: The Splendor of Light—Discover a brilliant celebration of light that's sure to inspire! This innovative collection contains over 120 full-color reproductions of today's best watercolor paintings, along with the artists' thoughts behind these incredible works. *#30809/$29.99/144 pages/124 color illus.*

Learn Watercolor the Edgar Whitney Way—Learn watercolor principles from a master! This one-of-a-kind book compiles teachings and paintings by Whitney and 15 of his now-famous students, plus comprehensive instruction—including his famed "tools and rules" approach to design. *#30927/$22.99/144 pages/130 color illus./paperback*

How to Get Started Selling Your Art—Turn your art into a satisfying and profitable career with this guide for artists who want to make a living from their work. You'll explore various sales venues—including inexpensive home exhibits, mall shows and galleries. Plus, you'll find valuable advice in the form of marketing strategies and success stories from other artists. *#30814/$17.99/128 pages/paperback*

Painting Watercolors on Location With Tom Hill—Transform everyday scenes into exciting watercolor compositions with the guidance of master watercolorist Tom Hill. You'll work your way through 11 on-location projects using subjects ranging from a midwest farmhouse to the Greek island of Santorini. *#30810/$27.99/128 pages/265 color illus.*

1997 Artist's & Graphic Designer's Market: Where & How to Sell Your Illustration, Fine Art, Graphic Design & Cartoons—Your library isn't complete without this thoroughly updated marketing tool for artists and graphic designers. The latest edition has 2,500 listings (and 600 are new!)—including such markets as greeting card companies, galleries, publishers and syndicates. You'll also find helpful advice on selling and showing your work from art and design professionals, plus listings of art reps, artist's organizations and much more! *#10459/$24.99/712 pages*

Basic People Painting Techniques in Watercolor—Create realistic paintings of men, women and children of all ages as you learn from the demonstrations and techniques of 11 outstanding artists. You'll discover essential information about materials, color and design, as well as how to take advantage of watercolor's special properties while rendering the human form. *#30756/$17.99/128 pages/275+ color illus./paperback*

In Watercolor Series—Discover the best in watercolor from around the world with this inspirational series that showcases works from over 5,000 watercolor artists. Each minibook is 96 pages long with 100 color illustrations.

 People—#30795/$12.99
 Flowers—#30797/$12.99
 Places—#30796/$12.99
 Abstracts—#30798/$12.99

Becoming a Successful Artist—Turn your dreams of making a career from your art into reality! Twenty-one successful painters—including Zoltan Szabo, Tom Hill, Charles Sovek and Nita Engle—share their stories and offer advice on everything from developing a unique style, to pricing work, to finding the right gallery. *#30850/$24.99/144 pages/145 color illus./paperback*

Watercolor: You Can Do It!—Had enough of trial and error? Then let this skilled teacher's wonderful step-by-step demonstrations show you techniques it might take years to discover on your own. *#30763/$24.99/176 pages/163 color, 155 b&w illus./paperback*

How to Capture Movement in Your Paintings—Add energy and excitement to your paintings with this valuable guide to the techniques you can use to give your artwork a sense of motion. Using helpful, step-by-step exercises, you'll master techniques such as dynamic composition and directional brushwork to convey movement in human, animal and landscape subjects. *#30811/$27.99/144 pages/350+ color illus.*

Creative Watercolor Painting Techniques—Discover the spontaneity that makes watercolor such a beautiful medium with this hands-on reference guide. Step-by-step demonstrations illustrate basic principles and techniques while sidebars offer helpful advice to get you painting right away! *#30774/$21.99/128 pages/342 color illus./paperback*

Creative Watercolor: The Step-by-Step Guide and Showcase—Uncover the innovative techniques of accomplished artists as you get an inside look at the unending possibilities of watercolor. You'll explore a wide spectrum of nontraditional techniques while you study step-by-step projects, full-color galleries of finished work, technical advice on creating professional looking watercolors and more. *#30786/$29.99/144 pages/300 color illus.*

The North Light Artist's Guide to Materials & Techniques—Shop smart with this authoritative guide to buying and using art materials in today's most popular mediums—from watercolor, oil and acrylic to charcoal, egg tempera and mixed media. You'll find personal recommendations and advice from some of North Light's most popular artists, as well as informed discussions on basic techniques, shopping lists, paints, surfaces, brushes and more! *#30813/$29.99/192 pages/230+ color illus.*